舊院妓女之怪

今昔妖怪大鑑
YOKAI MUSEUM
YUMOTO Koichi Collection
湯本豪一コレクション

はじめに Introduction

　自然に対する畏怖や心の不安が、妖怪を生み出したといわれる。
　天変地異や天候は、人の生命や生活に大きな影響を与えるにもかかわらずコントロールすることは不可能だ。いっぽうで、疫病の広がりは自分や家族の生命の危機にとどまらず、祖先から営々と引き継がれた共同体の存立をも脅かす根本的な恐れとして、人々の脳裏から離れることはなかった。昔から、生活はこうした環境と向き合いながら営まれていたのである。闇は身近なところに広がっていた。昼間は当たり前のように働いたり遊んだり、行き来していた田畑や道などが、夜になると人の支配を拒否するかのように漆黒の空間と化し、そこに何かの気配を感じることもあったに違いない。闇はけっして戸外だけではなく、家のなかにも忍び込んでいた。部屋は行灯の照明でほの暗く、人がいる場所以外は屋内といっても闇に包まれているほどだった。こうしたなかで、父祖たちは人智を超えた存在に思いを馳せ、やがて妖怪という生き物を生み出していった。
　命を与えられた妖怪は、やがて増殖を繰り返して人々の心にしっかりと棲みつき、跳梁跋扈していった。いっぽう父祖たちは、そうした妖怪たちを捉えようとし、ついにはその姿をビジュアル化した。私たちが目にする妖怪たちの世界はこうしてはじまった。
　今日まで妖怪たちの姿を伝えるさまざまな資料のうちでも古いものが絵巻だ。現存する最古の妖怪絵巻は、室町時代の土佐光信筆とされる京都・大徳寺真珠庵所蔵の百鬼夜行絵巻だ。絵巻には漆黒のなかで跳梁跋扈する妖怪たちが生き生きと描

It is said that man's fear of nature and anxieties gave birth to yokai.

　In our everyday lives, we confront the possibility of natural disasters, epidemics and other things over which we have no control. These things not only represent a crisis in our own life and in the lives of our family members, they create a fear that is visceral, a fear that threatens the very existence of the community of life we have inherited from our ancestors over countless generations, a fear that is never far from our minds. As the sun sets on the day, darkness spreads around us. The fields in which we work and play and the roads we travel back and forth on unthinkingly during the day, at nighttime turn into pitch-black space, as if defying the control of human beings, and the sense that something is lurking in that darkness is palpable. And it's not just outside. Inside the houses of old, dimly lit with paper lanterns, the places where no human being exists are shrouded in darkness. In such places, Japanese people began to believe in presences that were beyond human understanding, causing creatures, called yokai, to be created in their minds.

　The yokai that sprang to life in this way began to propagate. They set up residence in people's minds and there they remained, arrogant, domineering and running wild. Our ancestors tried to capture them in the form of drawings and there began the visual depiction of the world of yokai. Picture scrolls are the oldest form of yokai depiction that still exists today. The oldest of all extant yokai picture scrolls is the

かれており、人の気配は微塵も感じられない空間に妖怪たちだけの世界が繰り広げられている。百鬼夜行絵巻は、源頼光が鬼を退治する酒呑童子絵巻、煤払いのときに捨てられた器物たちが魂を宿して人に仇をする付喪神絵巻など人との関連で妖怪が登場する絵巻とは異なり、妖怪だけが描かれた絵巻としての嚆矢としても重要な存在だ。その後、百鬼夜行絵巻は描き継がれてもっともポピュラーな妖怪絵巻として大きな広がりをみせ、さまざまな場面が絵巻、錦絵、版本などに描かれていった。

江戸時代になるとさまざまな種類の妖怪絵巻が描かれるようになったが、形態的には、いくつもの妖怪を一点一点紹介した妖怪図鑑的絵巻、短い文章に絵を添えた妖怪譚を何点も収録した百物語的絵巻、巻頭から巻末までひとつのストーリーが展開されるスタイルなどに分類できる。内容的にも、化物のお見合いから結婚、出産、宮参りまでを描いた化物嫁入り絵巻、神農とその従者が放屁で妖怪を退治する神農妖怪退治絵巻などのように面白おかしいものまでも登場していった。

いっぽうで江戸時代は木版印刷発展の恩恵をうけて妖怪文化が飛躍的に広がった。絵巻は肉筆のため、制作される数には限りがあり、誰もが気軽に入手できるものではなかったが、木版による印刷によって同じものを大量に制作することが可能となり、安価で手にすることができるようになったのである。かくて、妖怪も錦絵や版本に描かれることによって身近な存在となり、やがては遊びのなかにも妖怪が登場するようになり、双六やカルタなどにもキャラクター化された愛らしい妖怪が描かれていった。こうした「怖くない妖怪」は現代にまで連綿と受け継がれ、さらなる広がりをみせている。

しかし、妖怪文化の広がりは単に錦絵や版本といった印刷物にとどまらなかった。着物、印籠、根付などの身につけるものから、鍔や小柄といった武具に至るまで妖怪がデザインされるようにな

Hyakki Yagyo (Night Parade of One Hundred Demons) painted in the Muromachi period by Tosa Mitsunobu in possession of the Shinjuan temple in Kyoto. In the pitch-blackness, where there is no sign of human life, a world of rampaging yokai vividly unfolds. Unlike other picture scrolls in which the yokai appeared through their association with human beings, such as the Shuten-doji Picture Scroll where Minamoto no Yorimitsu vanquishes demons or the *Tsukumogami* Picture Scrolls where household objects that were thrown away during the end-of-year cleaning became possessed by demons and caused harm to people, the importance of the Night Parade of One Hundred Demons lies in the fact that it marks the beginning of picture scrolls featuring solely yokai. Many different versions of the Night Parade of One Hundred Demons then followed. It spread throughout Japan as the most popular of the yokai picture scrolls and various scenes of yokai processions featured in picture scrolls, *nishiki-e* (multicolored woodblock prints), and woodblock printed books.

With the arrival of the Edo period, numerous types of yokai picture scrolls were being produced. They could be classified as illustrated guide-like picture scrolls that introduced each of a group of yokai individually, picture scrolls that contained short yokai stories accompanied by drawings, and those that developed a long story from the start of the scroll to the end. Some had humorous content such as the *Bakemono Yome-iri Emaki* (Monsters' Wedding Picture Scroll, page 182) depicting the monster's *omiai*, marriage, childbirth and visit to the shrine, and the picture scroll in which Shinno and his followers vanquished the yokai by breaking wind (page 52).

That said, because picture scrolls are hand-drawn, there is a limit to the number that are produced and they were not readily available to everyone. In the Edo period, mass production of

り、さらには納札や千社札など信仰に関わるものにも登場する。こうした傾向は、明治時代から現代にまで引き継がれ、幻灯の流行にともなって幻灯用のガラス種板や外国人向けに作られた神戸人形なども妖怪たちのフィールドとなり、駄菓子屋でもシール、カード、メンコ等々、子どもたちを楽しませるさまざまな妖怪グッズが売られていった。

　本書は、このような多様な妖怪文化の展開と長い歩みの軌跡を多くの原資料を紹介することで俯瞰することを目指している。日本のユニークな文化としての妖怪に、多少なりとも興味をもっていただければ幸いである。

<div style="text-align: right">湯本豪一</div>

凡例　Editor's notes
本書に掲載したコレクションは、すべて湯本豪一所蔵のものを使用した。
寸法の単位はすべてミリメートルである。
解説は当該ページに記載のほか、図版をできるだけ大きく掲載するために巻末へ記したものもある。
本書では、日本の文化・言語に通じていない人にも理解しやすいような表記・省略・読みがなを使用している箇所がある。
All works appearing in this book belong to the Yumoto Koichi Collection.
All dimensions are given in millimeters.
Descriptions of works appear on the respective pages, and where space was limited, at the back of the book.
This English text in this book has been edited or abridged in parts to make it readily understood by readers not familiar with the Japanese language or Japanese culture.

pictures was made possible by the advent of the woodblock print, and even the common folk were able to purchase inexpensive prints. Yokai became a familiar presence through their depiction in *nishiki-e* and woodblock-printed books and eventually also appeared in games, with adorable yokai characters drawn on board games and playing cards (Chapter 4). Benefitting from the development of woodblock printing, yokai culture spread dramatically. These endearing yokai characters were passed down in an unbroken line to the present day.

　The spread of yokai culture did not stop with printed materials. Yokai also appeared on items worn on the body such as kimono, obi, netsuke and inro, and weapons such as *kozuka* (a knife attached to the sheath of a sword) and the hand guards of swords. Now the subject of designs, yokai even appeared on items related to religious faith, such as *nosatsu* (votive tablets offered at a shrine) and *senjafuda* (slips of paper posted on the pillars of a shrine by pilgrims). In the Meiji period, they appeared on the glass slides that were part of the then craze for magic lanterns and on dolls created for foreigners. Even in the modern day, all kinds of yokai-related goods for children are available.

　The aim of this book is to provide an overview of the trajectory of the development of the culture around various yokai by introducing a number of original materials. We hope this book serves an impetus for the development of an even greater interest in the unique yokai culture of Japan.

<div style="text-align: right">Yumoto Koichi</div>

はじめに　Introduction　2

1　絵巻——妖怪の競演　6
　Picture Scrolls – A Cast of Colorful Yokai

2　妖怪本の世界　76
　The World of Yokai Books

3　錦絵——極彩色の世界　114
　Nishiki-e – A World of Gorgeous Color

4　妖怪遊び　158
　Yokai Games

5　生活のなかにひそむ妖怪　210
　Yokai Lurking in Everyday Life

6　祈りと妖怪　258
　Yokai and Prayer

コラム　Column

1　芭蕉と蕪村の妖怪体験　72
　The Yokai Experiences of Matsuo Basho and Yosa Buson

2　林家正蔵怪談噺関係妖怪絵　92
　Yokai Pictures Inspired by Hayashiya Shozo's Ghost Stories

3　北斎百物語　110
　Hokusai *Hyaku Monogatari*

4　極彩色の妖怪報道　144
　Nishiki-e Newspapers

5　本所七不思議　152
　The Seven Wonders of Honjo

6　化物嫁入り絵巻　180
　Bakemono Yome-iri Emaki

7　妖怪映画ポスター　208
　Yokai Movie Posters

作品解説　Description of Works　271

絵巻には平安時代からさまざまなテーマが描かれてきたが、妖怪を題材にした絵巻も数多くある。源頼光の鬼退治を描いた酒呑童子絵巻は、武将の勇猛ぶりが主題だ。また、煤払いのときに捨てられた器物たちが魂を宿して人間に仕返しを企てるものの仏道に帰依して成仏するといった内容の付喪神絵巻は、仏教の有難さを伝えることが主題で、鬼や妖怪は脇役的存在にすぎない。時代を経ると、このような初期の妖怪絵巻の性格とは大きく変化し、妖怪だけが描かれ、なに憚ることなく主役として跳梁跋扈する絵巻が登場する。その記念碑的存在が、妖怪たちの行列を描いた百鬼夜行絵巻だ。その後、妖怪を主題にしたさまざまな絵巻が描かれて、江戸時代には多様な妖怪絵巻の世界が展開されるようになる。

江戸時代の妖怪絵巻は、中世から描き継がれた百鬼夜行のようなものもあれば、地方に伝わる妖怪を描いたものなど実にさまざまだ。形態的にもストーリーが展開するもの、一つ一つの妖怪を紹介する妖怪図鑑的なもの、いくつもの短い怪異譚を絵をまじえて紹介したものなど、いくつかのスタイルも定着していった。

注：絵巻は右から左へと描かれています。
Note: Japan handscrolls unroll from right to left.

Many picture scrolls produced since the Heian period have had yokai as their subject. Yokai picture scrolls started out as a vehicle for extolling the virtues of Buddhism in which the demons and yokai played nothing more than a minor role. Thereafter, the nature of the yokai picture scrolls began to change and eventually, the yokai themselves took center stage. The most monumental of the yokai picture scrolls is *Hyakki Yagyo Emaki*, or the Night Parade of One Hundred Demons.

There are many different kinds of yokai picture scrolls from the Edo period, from those that feature night parades of one hundred demons passed down from the middle ages to the drawings of yokai that have proliferated throughout Japan. They took on various styles. Some of them tell a story, some adopt the style of illustrated reference books, and some are collections of short stories that are accompanied by pictures.

1

絵巻 ― 妖怪の競演

Picture Scrolls – A Cast of Colorful Yokai

① 百鬼夜行絵巻
ひゃっきやぎょうえまき
Night Parade of One Hundred Demons Picture Scroll (*Hyakki Yagyo Emaki*)

江戸時代　1巻　370×7775mm　Edo period, handscroll

※百鬼夜行絵巻とは、さまざまな妖怪たちが闇のなかを列をなしてどこかへ向かう様子、気ままに跳梁する姿を描いたもの。現存する最古の百鬼夜行絵巻は大徳寺真珠庵に伝えられる土佐光信筆といわれるもので、美術的価値も高く、国の重要文化財に指定されている。この絵巻は江戸時代より前の百鬼夜行絵巻で確認できる唯一のもので、百鬼夜行絵巻を語るときには必ず言及される。現在、江戸時代に描かれた百鬼夜行絵巻は数多く残るが、大半は真珠庵系の絵柄である。描き継がれるうちに登場する妖怪の順番が変化したり、新たな妖怪が入ったりしているものも多々ある。

百鬼夜行絵巻のなかには、土佐派や狩野派の一流の絵師が描いたと思われるものから拙い筆致の作品まで幅広く存在し、裾野の広さを裏付けている。いっぽうで真珠庵系とはまったく絵柄の異なった種

The Night Parade of One Hundred Demons (*Hyakki Yagyo*) shows a procession of various types of rampaging yokai, setting off for some unknown destination through the darkness. The oldest extant Night Parade of One Hundred Demons Picture Scroll, believed to have been painted by Tosa Mitsunobu, belongs to the Shinjuan sub-temple of Daitokuji in Kyoto. It has been designated an important cultural property for its high artistic value. The only *Hyakki Yagyo Emaki* confirmed as existing before the Edo period, it is always referred to in any discussion about One Hundred Demons Picture Scrolls. A number of *Hyakki Yagyo Emaki* painted in the Edo period still exist today, most of which were painted in the "Shinjuan style." In many later picture scrolls, the artists changed the order in which the yokai appeared or introduced some new

①

類のものも存在しており、いくつかの系統があったと思われるが、その全容の解明は今後の課題といえよう。百鬼夜行絵巻の絵柄は他の妖怪絵巻にも引用されているが、明治時代以降も描かれ、パロディ化された作品なども登場している。

kinds of yokai. The quality of *Hyakki Yagyo Emaki* varies widely – from those believed to have been painted by leading masters of the Tosa and Kano schools to others with their clumsy brushwork, all of which form the broad base of this type of picture scroll. Some depart vastly from the Shinjuan style and it is believed that a number of different styles existed.

 The design of the *Hyakki Yagyo Emaki* has been referenced on other picture scrolls also. Since the Meiji period, picture scrolls parodying the one hundred demons have also appeared.

1

13

この図柄は延々と描き継がれ、江戸時代にも数多く描かれている。そのなかには描かれた妖怪は同様であるものの登場する順番が違っているケースも少なくないが、この絵巻もそうしたものの一つである。また、絵巻全体に青の雲とも霞ともつかぬ柄が施されている。これは闇をイメージしたものだろうが、こうしたところがこの絵巻独自の工夫で、古くからの図柄を踏襲しながらも絵師のオリジナリティがうかがえる。

This picture scroll faithfully adheres to the Shinjuan-style, except for the order in which the yokai appear as the scroll is unrolled. A blue pattern has been applied throughout, most likely to express darkness. With this the painter has managed to adhere to the style of the older picture scroll but also add his own unique touch.

真珠庵系とは別系統の妖怪も含まれた絵巻の下絵である。

This sketch also contains different yokai from those in the Shinjuan scroll.

15

1

② 百鬼夜行絵巻
ひゃっきやぎょうえまき
Night Parade of One Hundred Demons Picture Scroll

江戸時代　1巻　385×3990mm　Edo period, handscroll

ふらり火　Slow crawling fire

真珠庵系の絵巻に別系統の百鬼夜行絵巻を加えているが、妖怪図鑑的絵巻に登場する髪切などの妖怪が挿入されている箇所があり、この絵巻の特徴としてあげられる。また、最後の場面は大きな火の玉でなく、ふらり火となっていることも特筆できる。絵巻全体の上下部分にたなびく雲のような模様が描かれているが、これは闇をイメージし、そこに跳梁する妖怪たちの姿をあらわしているのだろう。

Based on a Shinjuan-style picture scroll, this scroll is characterized by the insertion of yokai such as the *kamikiri* that appear in illustrated-guide-like picture scrolls. The final scene is notable for, not the typical large fireball, but a slow-crawling fire. At the top and the bottom of the entire scroll, a pattern of wispy clouds is drawn to suggest darkness from which appears the sight of the yokai on the march.

③ 百鬼夜行絵巻
ひゃっきやぎょうえまき

Night Parade of One Hundred Demons Picture Scroll

江戸時代　1巻　315×8620mm　Edo period, handscroll

真珠庵系の妖怪を中心に描かれ、そのなかにいくつかの別系統の百鬼夜行絵巻の妖怪が交じっているが、図の複数箇所に色指定などの情報が書かれていることや、淡彩ということから、この絵巻は完成型の一つ手前の下絵なのかもしれない。

Here a few other kinds of yokai have been mixed in with the mainly Shinjuan-style yokai. Several of the drawings have color-coding information attached. The pale colors suggest that this picture scroll was still in the pre-completion stage.

百鬼夜行絵巻にはいくつもの下絵も存在する。他の妖怪絵巻では下絵がほとんど確認されていないことと比較すると大きな違いだ。下絵のなかにはそれぞれの妖怪に色指定などが記されているものもあり、百鬼夜行絵巻研究にも重要な資料となっている。

A number of sketches for Night Parade of One Hundred Demons Picture Scrolls are in existence, which is significant in that few sketches have been found for other types of yokai picture scrolls. Some of the sketches contain color-coding information for each of the yokai. The sketches have proved to be an invaluable resource in the research of Night Parade of One Hundred Demons Picture Scrolls.

真珠庵系の絵柄がメインとなっているが、別系統の絵柄（左下の鞍の妖怪など）も入り込んでいる。

The design is mostly in the Shinjuan-style but other yokai (the creature at the bottom left, for example) have also been incorporated.

25

④ 百鬼夜行絵巻
ひゃっきやぎょうえまき
Night Parade of One Hundred Demons Picture Scroll
江戸時代　1巻　270 × 4500mm　Edo period, handscroll

27

4

5 百鬼夜行絵巻
ひゃっきやぎょうえまき
Night Parade of One Hundred Demons Picture Scroll
江戸時代　1巻　355×6285mm　Edo period, handscroll

32

6

百鬼夜行図巻
ひゃっきやぎょうずかん

Night Parade of One Hundred
Demons Picture Scroll

江戸時代　狩野宴信　1巻　260×638mm
Edo period, Kano Enshin, handscroll

⑦ 化物づくし絵巻
ばけものづくしえまき

Bakemono-Zukushi Picture Scroll

江戸時代　1巻　281 × 326mm
Edo period, handscroll

図は波間から上半身を出して尖った口で汐を噴き上げている大きな耳が特徴の「汐吹」、赤い目に大きな鼻と耳が特徴的でガウンのような衣服を身につけた「馬肝入道」、上半身と足首から下が描かれていない特異な姿だが、太い尾や手の指などから狸などの獣類が化けたことを想像させる「為何賊」など。

The drawings show a *shiofuki* with its characteristically large ears and pointed mouth, its upper body emerging from between the waves and spraying sea water from its mouth; a *bakkan nyudo*, with its characteristically red eyes and large nose and ears, wearing what looks like a gown; and a *nanjaka*, with its peculiar body rendered with nothing above the waist or below the ankles, but its thick tail and paw-like fingers make us think that it was originally an animal such as a raccoon that turned itself into a yokai.

まっぴら　*Mappira*

なんじゃか　*Nanjaka*

にくらし　*Nikurashi*

うやうやし　*Uyauyashi*

馬肝入道　*Bakkan nyudo*

汐吹　*Shiofuki*

8 化物づくし絵巻
ばけものづくしえまき

Bakemono-Zukushi Picture Scroll

江戸時代　1巻　269 × 3502mm
Edo period, handscroll

ぬらりひょん　*Nurarihyon*

9 化物づくし絵巻

Bakemono-Zukushi Picture Scroll

江戸時代　狩野由信　1巻　Edo period, Kano Yoshinobu, handscroll

妖怪図鑑的絵巻で35種類の妖怪が収録されている。その多くは他の絵巻にも描かれているが、犬か獅子のような姿をした三つ目の動物は他の絵巻では未見で、同じ図がアメリカのブリガムヤング大学に所蔵されている絵巻に「ぬりかべ」として収録されていることが確認されて、それまではビジュアル資料が伝えられていないといわれた「ぬりかべ」が描かれた絵巻として注目された。それまで「ぬりかべ」という妖怪は伝えられていたものの絵は存在しないといわれ、水木しげるは伝承をベースに白色の四角い姿として描いている。この絵巻は巻頭に「叙」、巻末に「跋」が書かれていることも大きな特徴である。その記述から泰歳なる人物が命じて戯作者の平澤月成が文を撰し、由信が絵を担当して成立したことがわかる。由信は南部藩のお抱え絵師で文政3（1820）年没。「跋」からこの絵巻は享和2（1802）年作であることがわかる。

The yokai called "*nurikabe*" was legendary, but no picture of him existed. Based on information that had been handed down, manga artist Shigeru Mizuki drew the *nurikabe* as a white square and this is how he has been depicted ever since. Then, a picture scroll with the same picture of the blobby yokai that looks like a three-eyed lion or dog as the one in this picture scroll was discovered in the United States. The word "*nurikabe*" was written next to the picture, from which it was ascertained that the monster here is the nurikabe. The picture scroll shown here is the only known picture scroll in Japan that features the *nurikabe*.

跋　Afterword　　　叙　Introduction

図の左から「ぬりかべ」、「海男」。　From left to right are the *nurikabe* and *umi-otoko*.

10 百物語化絵絵巻
ひゃくものがたりばけええまき

Hyaku Monogatari Bake-e Picture Scroll

江戸時代　方郁　1巻　295 × 6240mm　Edo period, Hoiku, handscroll

41

かみきり　*Kamikiri*

しらちご　*Shirachigo*　　　とうびょう　*Tobyo*

がごぜ　*Gagoze*

11　化物づくし絵巻
ばけものづくしえまき

Bakemono-Zukushi Picture Scroll

江戸時代　1巻　289cm × 6485mm　Edo period, handscroll

図は一般的には天狗の子供のような姿なのに対して、虫のような関節を持った姿に描かれた「かみきり」、屏風の中から半身を現す「がごぜ」など、他の妖怪図鑑的絵巻とは異なった絵柄だ。蛇の妖怪「とうびょう」はこの絵巻以外では未見。

The yokai in this scroll appear different from those in other illustrated-reference-book-like picture scrolls: the *kamikiri* generally depicted as a child-like *tengu* (long-nosed goblin), here he has what look like the joints of an insect, and the gagose peers out from behind a folding screen. The snake yokai tobyo is seen in no other scroll.

図は丹波から山城に向かっていた旅人が遭遇した古井戸から出てきた白髪の妖怪、近江の寺の炬燵から現れた赤入道、常陸国鹿島郡の長者塚から出現した妖怪。
Shown here the stories of a white-haired yokai emerging from an old well that is encountered by a traveler who has left Tanba heading for Yamashiro; an *akanyudo* (red, bald-headed yokai) appearing from the *kotatsu* in a temple at Omi; and a yokai that emerges from the Chojazuka burial mound at Kashima-gun in Hitachi-no-kuni.

12

ばけもの絵巻
ばけものえまき

Bakemono Picture Scroll

明治時代　1巻　310 × 5485mm
Meiji period, handscroll

近江の国武佐の宿なる寺の
籔より赤坊主といふ
もの出まうし
沙汰しける
人通ても
をとれをあらし
とりあることあり
とる男あれは
事ありて菖をと
りと置て宇書とり
ことつにあらわれ
空甲に迷ひつゝ沙を盆
きたき中と抱りあらや
あきや
そて目え又とたの中に赤
道おちと出ちと子物あらむの昔
ナあり

大槌といふ所の田の中に蔵あり役様
あり月あを九一宮ふの
たのみあり

ある人北邦近より山ゟこし
通に進ひ野原に日なくて
せん方なく草木にうれ
伏して風雨にふらふら
ちちきゝ風吹わとう
たちまちあら古井
の中にうめく
あとあり

孝徳の御廃んの頃に
菖芥塚とふあり廻番
ありたぬ主なりとて垣を
結ひて柴一むをに

変化絵巻
へんげえまき

Henge picture scroll

江戸時代　全3巻　(上) 320 × 13000mm　(中) 320 × 12880mm　(下) 320 × 15330mm
Edo period, set of three handscrolls, (vol.1) 320 × 13000mm, (vol.2) 320 × 12880mm, (vol.3) 320 × 15330mm

丹後国の武士津田藤十郎利信の屋敷に出現するさまざまな妖怪が描かれている。これらの妖怪は屋敷に棲みついた狐の仕業によるもので、巻頭には狐を追い払う屋敷の人々が描かれている。ついで一つ目入道、不動明王、蟹の化物、大入道、竜、牛鬼などがつぎつぎと現れ、さらには怪火や器物が座敷を舞うポルターガイスト現象などの怪異もあって家人を恐怖に陥れる。最後には狐を退治して平穏に戻るというストーリー。

Stories about yokai that appeared in the mansion of samurai Tsuda Tojuro Toshinobu in Tango-no-kuni. The yokai were conjured up by the machinations of a fox that lived in the mansion (in Japan it is believed that foxes can turn themselves into many different things), and the scroll opens with the people living in the mansion chasing the fox away. One by one, they appear – a one-eyed *nyudo*, a *fudomyoo* (Acala), a crab monster, a giant *nyudo*, a dragon and a cow demon. On top of that, a fire of suspicious origin and a poltergeist-like presence of utensils hovering around the house terrorize its inhabitants, but in the end, they are vanquished and peace returns to the house.

48

49

14 二才絵巻
にさいえまき

Nisai Picture Scroll

江戸時代　1巻　263×16300mm
Edo period, handscroll

薩摩藩士の大石兵六が人を化かす狐を退治に山に入り、狐の仕業によるさまざまな妖怪の出現にもめげず、最後は退治した狐を戦果として持ち帰るといった内容。図は山中で兵六の前に出現したさまざまな妖怪。

This picture scroll shows the story (generally referred to as the Oishi Hyoroku Story) of the feudal retainer of the Satsuma Domain, Oishi Hyoroku, who went into the mountains to vanquish a fox who turned into a human being. Oishi stands his ground as various yokai conjured up by the machinations of the fox appear. In the end, Oishi brings the vanquished fox back home as the spoils of war. Shown here are some of the various yokai that appeared before Oishi Hyoroku.

15 神農鬼が島退治絵巻
しんのうおにがしまたいじえまき

Shinno and the Vanquishing of the Yokai
on the Mythical Island of Demons Picture Scroll

江戸時代　1巻　255 × 9450mm　Edo period, handscroll

人民を悩ます妖怪を神農が猿丸太夫、鳥海弥三郎、犬坊丸を従えて妖怪のいる島に退治に出かけて退散させるというストーリーで、従者の名前からも桃太郎の鬼退治をベースにした妖怪譚絵巻であることがうかがわれる。神農は妖怪退治の武器として芋と栗を準備して島に乗り込み、大王にお目通りを果たす。機をみて神農と3人の従者は持ってきた芋と栗を腹いっぱい食べて妖怪たちに放屁による一斉攻撃をかけて降参させる。かくて、大王は今後は人々を苦しめないと約束して海のかなたに去っていく。

15. A story in which Shinno, accompanied by a band of followers he called by the names of Monkey, Bird and Dog, sets out for an island on which yokai that were tormenting the people lived, in order to vanquish them, and sends them fleeing. It can be gathered from the names of the followers also that this yokai-story picture scroll was based on the vanquishing of the demons in the Momotaro story. Shinno prepares weapons of potatoes and chestnuts for his vanquishing of the monsters, alights on the island, and has an audience with Daio (the great king). Seeing an opportunity, Shinno and his three followers stuff themselves with the potatoes and chestnuts they had brought, and pass wind in unison as a form of attack, causing the yokai to surrender. Thus, Daio promises that the yokai would not bother the people again and disappears into the sea.

55

片輪車　*Katawaguruma*

いくつもの妖怪を紹介した妖怪図鑑的絵巻。12種類の妖怪を収録している。妖怪図鑑的絵巻のなかには60種類近く描いているものも存在していることから、収録数はけっして多いとはいえないが、パターン化され描き継がれた構図とは異なり、作者のオリジナリティによる妖怪像も多々あり、独自の世界を展開している。片輪車は赤子をかみ殺して不気味な視線をこちらに向けている。右下の図は屏風の裏から首を出した見越入道。右上は長い牙のある顔で睨みつける土蜘蛛。手には金色の蜘蛛糸を持って獲物を狙っている。

An illustrated-reference-book-like picture scroll showing 12 types of yokai. Many of the images of the yokai are a product of the creative imagination of the artist, and in this picture scroll, he has created a unique world. Shown here, the *katawaguruma* has bitten a baby to death and now turns its sinister gaze towards us; the *tsuchigumo*, with long fangs and a glaring face, in his hands holds golden spider's web with which he tries to catch his prey; and a *mikoshi nyudo*, who has stuck his neck out from behind a folding screen.

16 お化け絵巻
おばけえまき

Obake Picture Scroll

明治時代　岡島陽城　1巻　Meiji period, Okajima Yojo, handscroll

土蜘蛛　*Tsuchigumo*

見越入道　*Mikoshi nyudo*

17 付喪神絵巻
つくもがみえまき

Tsukumogami Picture Scroll

江戸時代　全2巻　(上) 269 × 1010mm　(下) 269 × 955mm
Edo period, set of two handscrolls, (vol.1) 269 × 1010mm, (vol.2) 269 × 955mm

59

60

護法童子に追われて逃げ惑う、妖怪と化した器物たち。
In the scene shown here, the household-objects-turned-yokai are running from Goho-doji who is chasing them.

「百鬼夜行」と題された絵巻は、大徳寺真珠庵に伝わる百鬼夜行絵巻をはじめとして数多く確認されており、描かれた内容も種々あるが、この絵巻は茶器の妖怪たちが跳梁する特異な存在だ。茶碗、茶筅、棗を先頭に、湯の沸いた茶釜や茶杓を持った茶釜らがどこへか急いでいる。それを追いかけるように闇のなかを炭入や盆が走り来る様子が描かれている。

A picture scroll of tea-utensil yokai on the rampage. With teabowl dipper in hand, the iron tea ceremony pot of water boiling is on the march. Through the darkness, the charcoal basket, tray and other implements come running in pursuit.

18 百鬼夜行絵巻
ひゃっきやぎょうえまき

Night Parade of One Hundred Demons Picture Scroll

江戸時代　塩川文麟　1巻　310 × 1320mm
Edo period, Shiokawa Bunrin, handscroll

お化の図宝洒落をいふ
上手者たる男地をうつて指を
ヱめの忍八山本五郎左ヱ門と云を天より
まもらん五祖ル三男の王もん引
人をたらかしヱつふ初様のハ

題箋に「百物語 天(地)」とあるが、内容は備後三次の稲生平太郎が体験した数々の怪異を描いたもので、一般的には「稲生物怪録絵巻」などと呼ばれている。稲生物怪録は写本、絵本、絵巻など、さまざまな形式で伝えられているが、絵巻はその内容から2種類に分類される。この絵巻はポピュラーなタイプで、1ヶ月にわたって稲生家に出現した妖怪や怪異を時系列で2巻に収録している。
The scroll depicts the various ghosts encountered by Ino Heitaro of Miyoshi Domain in Bingo-no-kuni (modern-day Hiroshima Prefecture). It is referred to, among other names, as *Ino Bukkai Roku Emaki* (The Ghost Experience of Mr. Ino), and records in chronological order across two scrolls all the yokai and mysterious phenomena that appeared in the Ino household during a one-month period.

19 百物語絵巻
ひゃくものがたりえまき

Hundred Ghost Stories Picture Scroll (*Hyaku Monogatari Emaki*)

明治時代　林熊太郎　全2巻
(天) 263 × 16570mm　(地) 263 × 17450mm
Meiji period, Hayashi Kumataro, set of two handscrolls, (vol.1) 263 × 16570mm　(vol.2) 263 × 17450mm

20 稲生物怪録絵巻
いのうぶっかいろくえまき
Ghost Experience of Mr. Ino Picture Scroll (*Ino Bukkai Roku Emaki*)

江戸時代　1巻　310×21450mm　Edo period, handscroll

芭蕉と蕪村の妖怪体験
The Yokai Experiences of Matsuo Basho and Yosa Buson

コラム Column 1

芭蕉翁行脚怪談袋　*Basho-o Angya Kaidanbukuro*

松尾芭蕉と与謝蕪村といえば、誰でも知っている俳諧の巨匠で、文学の歴史にも燦然と輝いている人物なのだが、興味深いことにその彼らの妖怪体験が記録されている。芭蕉が諸国を行脚した折に見聞きした怪異をまとめたものが『芭蕉翁行脚怪談袋』で、美濃、伊勢、京都、上州館林など各地での出来事を収録している。旅を住処としていた芭蕉だからこその〈妖怪との遭遇という〉意外な一面を垣間見ることができる資料である。

Everyone has heard of Basho and Buson, masters of haiku and shining lights of Japanese literary history, but intriguingly, their experiences with yokai are also documented. The strange phenomena that Basho saw and heard about on his travels around Japan are collected in *Basho-o Angya Kaidanbukuro*, which records happenings in Mino, Ise, Kyoto, Tatebayashi in Joshu (Gunma), and elsewhere. *Kaidanbukuro* gives a glimpse into an unexpected side of Basho, that is, his encounters with yokai, a product in large measure of his peripatetic lifestyle.

いっぽう、蕪村も各地で耳にした怪異譚を記録しているが、蕪村は絵にも才があったことから文章に絵を添えるというスタイルで妖怪たちを伝えている。この絵はもともとは蕪村が寄寓していた宮津（現在の京都府宮津市）の寺の欄間に貼られていたと伝えられており、榊原氏の古屋敷の化け猫、赤子の怪など8種の妖怪譚が『蕪村妖怪絵巻』に収録されている。ここで紹介しているのは昭和3(1928)年に限定複製されたもの。

Buson too recorded the scary tales he heard around the country, however also possessing a talent for drawing, he supplemented his yokai descriptions with illustrations. Said to have been stuck to the transoms of a temple in Miyazu (in current Kyoto Prefecture), where Buson had lodged, the Buson Yokai Picture Scroll includes eight types of yokai story; such as the shape-shifting cat of the old Sakakibara mansion, and story of the demon babies. The volume shown here is a limited edition copy published in 1928.

蕪村妖怪絵巻　Buson Yokai Picture Scroll

74

猫またちつちをおどろうぞ
胴ぞうをたゝいてこゝを
うてよえりれむ楠葉
心よ〱おかい五十目玉を
中だめにおけるに猫又の
腹より玉飛リーして出く
まするみるふま川いるとそ

あれつをゝの
かしをなめて
ゐあれにやん〱

おれのはらの
かわをためして
みおれ
にやんにやん

小笠原佐〻木尾張に
林一角法師つかいするに起立て
殺百人の芝者で踊る體まねえ
いるに起おを当る押明うふに
いるに私千の赤またつゝ川し
一角惜をなぐり
行きよれ候

蕪村妖怪絵巻　Buson Yokai Picture Scroll

江戸時代における妖怪文化の広がりに大きく貢献しているのが数々の妖怪本だ。とりわけ木版印刷による出版文化の発展がさまざまな妖怪本を世に送り出して妖怪を人々に近づけていった。『画図百鬼夜行』『絵本百物語（桃山人夜話）』などの妖怪図鑑的版本や妖怪たちの面白い話が絵と文章で展開される草双紙類を始めとして多種多様の妖怪本が存在する。いっぽうで、『稲生物怪録』や『大石兵六』といった肉筆の妖怪本も伝えられている。

The many yokai books that were produced made a significant contribution to the proliferation of yokai culture in the Edo period. People developed a sense of familiarity with the various yokai, introduced to the world through the various yokai books that were the product of a burgeoning publishing culture made possible by woodblock printing techniques.

The yokai books came in various forms including illustrated books such as *Gazu Hyakki Yagyo* (Illustrated Night Parade of One Hundred Demons) and *Ehon Hyaku Monogatari* (Picture Book of a Hundred Stories) and the various types of *kusazoshi* that had text and pictures of interesting stories about the yokai. There were also the hand-drawn yokai books such as the *Ino Bukkai Roku* (The Ghost Experience of Mr. Ino) and *Oishi Hyoroku Yume Monogatari* (The Dream Tales of Oishi Hyoroku).

2

妖怪本の世界
The World of Yokai Books

21 画図百鬼夜行
がずひゃっきやぎょう

Illustrated Night Parade of One Hundred Demons
(*Gazu Hyakki Yagyo*)

安永5年　鳥山石燕　全3巻　1776, Toriyama Sekien, three volumes

ひょうすべ　Hyosube

しょうけら　Shokera

78

鳥山石燕による妖怪図鑑的版本。3冊で構成され51種類の妖怪を収録。
A set of books of yokai drawings produced by Toriyama Sekien based old yokai drawings and folklore. These groundbreaking books feature 51 kinds of yokai.

見越　*Mikoshi*　　　　ろくろくび　*Rokurokubi*

がごぜ　*Gagoze*　　　　ぬらりひょん　*Nurarihyon*

22 怪物画本
かいぶつがほん
Illustrated Book of Monsters

明治14年　画・李冠光賢　模写・鍋田玉英
1881, drawings by Rikan Mitsukata, copied by Nabeta Gyokuei

猫また　Nekomata

やなり　Yanari

葵の上　*Aoinoue*

大仏怪物　*Daibutsu kaibutsu*

収録されている妖怪は鳥山石燕の『画図百鬼夜行』に描かれているもの。木版多色刷り。
The yokai featured in this book are the ones depicted by Toriyama Sekien in the Illustrated Night Parade of One Hundred Demons printed as full-color woodcuts.

23 絵本百物語
えほんひゃくものがたり
Picture Book of a Hundred Ghost Stories (*Ehon Hyaku Monogatari*)

天保12年　作・桃山人　画・竹原春泉斎　全5巻
1841, text by Tosanjin, drawings by Takehara Shunsensai, five volumes

山地々　*Yamachichi*

つつがむし　*Tsutsugamushi*

小豆あらい　*Azukiarai*

別名『桃山人夜話』。
Also known as *Tosanjin Yawa* (Tosanjin Night Stories).

24 写本　桃山人夜話
しゃほん　とうさんじんやわ
Handwritten Copy of *Tosanjin Yawa*

江戸時代　Edo period

『絵本百物語』（桃山人夜話）の文章部分だけを書き写したもので、このような写本の存在からも上記の版本が広く読まれていたことがうかがわれる。

Here only the text part of the Picture Book of a Hundred Ghost Stories have been transcribed. The fact that copies such as these exist tells us that the above picture book was widely read.

豆狸 いさゝよ小雨ふる夜を陰嚢をかつきて肴を求もとむといふ

豆狸　Mametanuki

深山草化物新話（黄表紙）
みやまぐさばけものしんわ

Miyamagusa Bakemono Shinwa (yellow-covered)

享和3年　作・夢中庵作三　画・勝川春英　全2巻
1803, text by Muchuan Sakuzo, drawings by Katsukawa Shunei, two volumes

※江戸時代の通俗的な絵入りの読み物として人気を博したのが草双紙だ。草双紙は表紙の色から赤本、黒本、青本、黄表紙などに分類され、また、内容が長編になったために数巻を合わせて1冊として刊行された合巻とよばれるものもある。草双紙に登場する妖怪たちは決して畏怖すべき存在だったりはしない。おっちょこちょいだったり、面白かったりして、親しみやすいキャラクターとなっている。草双紙の人間臭い妖怪たちは江戸時代の妖怪文化を特徴づける事象の一つだ。

The *kusazoshi* were popular illustrated reading material in the Edo period. *Kusazoshi* were classified according to the color of their cover: red, black, blue, or yellow. Because they now contained long as opposed to short stories, there were also versions called *gokan* in which several volumes of a story were combined into one book and a number of them published. The yokai that appeared in the *kusazoshi* were never scary ones. Instead they were goofy, funny and friendly characters. The human-like yokai of the *kusazoshi* were one of the phenomena characterizing the yokai of the Edo period.

26 化物和本草（黄表紙）
ばけものやまとほんぞう

Bakemono Yamato Honzo (Yellow-covered)

寛政10年　作・山東京伝　画・可候　全3巻
1798, text by Santo Kyoden, drawings by Kako, three volumes

化皮太鼓伝（合巻）
ばけのかわたいこでん

Bakenokawa Taikoden (Gokan)

天保4年　作・十返舎一九
画・歌川国芳　全6巻
1833, text by Jippensha Ikku,
drawings by Utagawa Kuniyoshi, six volumes

28

化物念代記（合巻）
ばけものねんだいき

Bakemono Nendaiki (Gokan)

文政2年　作・藍亭晋米　画・歌川国丸　全2巻
1819, text by Aitei Shinbei,
drawings by Utagawa Kunimaru, two volumes

29 大時代唐土化物（合巻）

おおじだいからのばけもの

Ojidai Karano Bakemono (Gokan)

文化8年　作・振鷺亭　画・勝川春亭　全3巻
1811, text by Shinrotei, drawings by Katsukawa Shuntei, three volumes

30 肉筆　怪談模模夢字彙
にくひつ　かいだんももんじい
Kaidan Momonjii

江戸時代　Edo period

31 怪談模模夢字彙（黄表紙）
かいだんももんじい
Kaidan Momonjii
(Yellow-covered edition)

享和3年　作・山東京伝　画・北尾重政　全3巻
1803, text by Santo Kyoden,
drawings by Kitao Shigemasa, three volumes

黄表紙の『怪談模模夢字彙』を肉筆で描いている。版本（下）と比較すると数丁の欠落がみられ、絵も多少異なる箇所がある。このような肉筆本がどのような理由で作られたかは不明で今後の調査が待たれる。

A hand-drawn rendition of the yellow-covered ghost story glossary *Kaidan Momonjii*. When compared to the printed edition, it has some missing pages and slightly different pictures.

林家正蔵怪談噺関係妖怪絵

コラム Column 2

Yokai Pictures Inspired by Hayashiya Shozo's Ghost Stories

　歴代の林家正蔵は怪談を得意としていたが、この絵は正蔵の怪談噺に際して何人もがそれぞれの怪談絵を描いたもの。怪談会は各地でさまざまな趣向で行われていたことが知られており、なかには作家、俳優など著名人も多数参加して開催されるケースもあった。怪談会は怪談を噺すだけでなく、会場に怖さを盛り上げるさまざまな趣向も凝らされて雰囲気を盛り上げた。いっぽう、噺家らの怪談噺も人気を呼び、口演を記録した書籍も何種類も出されているくらいだ。ここに紹介した怪談絵も林家正蔵の噺に際して集まって描いたもので、怪談をめぐる遊びの一端がうかがわれる資料といえる。

怪談会記念手拭および袋
Kaidankai commemorative hand towel
Towel bag

昭和5年
手拭 950 × 330mm
袋 175 × 110mm
1930,
Towel: 950 × 330mm
Bag: 175 × 110mm

表 Front　　裏 Back

Hayashiya Shozo were master ghost story tellers. These ghost story pictures, each drawn by a different artist, were inspired by Shozo ghost stories. The drawings give us an insight into the variety of amusement involving ghost stories.

怪談会記念に制作された手拭で、幽霊が影絵のように描かれ、その横には火の玉もみえ、左下には「なごや怪談会」とある。手拭の入っていた袋の裏面には昭和5年5月24日に小川町の寺で怪談会が開催されたことが記されている。

Kaidankai (ghost story gatherings) were set up in a number of different forms in every part of Japan. Various devices were used (not just the telling of ghost stories) to raise the level of fear at the meeting venues and to make the atmosphere more exciting. The ghost stories told by professional storytellers were also popular. Several different types of books were published containing transcripts of their oral performances.

32 稲亭物怪録
とうていぶっかいろく
Totei Bukkai Roku
明治3年　全2巻　1870, two volumes

備後三次の稲生家に起こった怪異を記した写本はいくつも残されているが、そのほとんどは文章だけで記録されている。この写本は文章に絵を交えた構成で、本書で紹介した稲生物怪録絵巻（p70）に対応する内容は、確認された事例がきわめて少ない。
There are several surviving documents that record the strange goings-on occurring in the Ino household but most of them are in written form only. In this hand-written copy, the text has been interspersed with pictures. Very few such copies have been confirmed. Its content is equivalent to that of the Ghost Experience of Mr.Ino Picture Scroll (page 70) introduced in this book.

大石兵六

33 大石兵六
おおいしひょうろく
Oishi Hyoroku
江戸時代　Edo period

97

34 稲生物怪録
いのうぶっかいろく

Ino Bukkai Roku

江戸時代　Edo period

備後・三次の稲生家に起った怪異を記した写本はいくつも残されているが、その稲生家の怪異を記録した絵本で、文章は一切書かれていない。内容は本書で紹介した林熊太郎「百物語絵巻」(p64)と同様である。

A picture book (with no text at all) depicting the strange goings-on in the Ino House. Its content as the same as that of the Hundred Ghost Stories Picture Scroll drawn by Hayashi Kumataro that has been introduced in this book (page 64).

※江戸時代からいわゆる豆本が出されていたが、そのなかに妖怪を扱ったものもある。これらの豆本は読むというよりもグッズ的なものとしてつくられたのだろう。そこに登場する妖怪は草双紙と同じく怖くないものばかりだ。

The so-called *mame-hon* (miniature book less than 10cm tall or wide) published from the Edo period were probably sold as novelty goods rather than as reading material. Similarly to the *kusazoshi* books, none of the monsters appearing in the *mame-hon* were scary.

35 化もの十二ヶ月（豆本）
ばけものじゅうにかげつ

Twelve Months of *Bakemono* (Miniature Book)

明治時代　120 × 80mm　Meiji period

36

金時化物退治（豆本）
きんときばけものたいじ

Kintoki Vanquishes the Yokai (Miniature Book)

明治22年　116×74mm　1889

37

化物（豆本）
ばけもの

Bakemono (Miniature Book)

江戸時代　92×59mm　Edo period

38 狂歌百鬼夜興
きょうかひゃっきやきょう

One Hundred Demons Night Performance of Comic Tanka

天保元年　編・菊廼屋真恵美　画・桂青洋、虎岳　230 × 164mm
1830, Edited by Kikunoya Maemi, drawings by Katsura Seiyo and Kogaku

江戸時代には何人もが集まって怪談を話す百物語会が流行していたが、天明5（1785）年には妖怪についての狂歌を詠む催しが行われた。その影響をうけて文政12（1829）年に開催されたときの妖怪狂歌を収録したもので、多色刷りの絵もふんだんに取り入れ、それぞれの妖怪に名前も添えている。

In the Edo period, "hundred ghost story" parties, in which several people gathered together to tell ghost stories, were popular. *Kyoka* are a form of tanka, composed according to a 5-7-5-7-7 rhythm, that contain social satire, irony and humor.

1丁に1つの妖怪を描き、横に歌を添えている。絵は同じ筆致だが、歌は別々の人によって詠まれ、書かれたようだ。漢文が添えられたものや歌が詠まれていない妖怪もあり、下書き的要素を持っている。こうした資料も妖怪狂歌の広がりを知ることのできる資料といえよう。

Each page contains a drawing of one yokai and beside the yokai are the words of a poem. The brushwork of the drawings is the same on all of them, but the poems seem to have been composed and written down by different people.

39

百鬼夜行肉筆戯画帖
ひゃっきやぎょうにくひつぎがちょう

Night Parade of One Hundred
Demons Caricature Album

江戸時代　303 × 212mm　Edo period

ほら貝　Triton

40

化物歌合せ
ばけものうたあわせ

Bakemono Uta-awase

江戸時代　6枚
Edo period, six sheets

1枚に1、2点の妖怪を描き、横に歌を添えている。妖怪をテーマにして歌の優劣を競う歌合せを記録した肉筆断簡で、妖怪狂歌の流行を知ることのできる資料といえよう。

Uta-awase is a game in which two groups of poets stand to the left and right and compete to determine which are the better poets. The hand-drawn drawings here show an *uta-awase* with a yokai theme.

天狗　Tengu

のっぺらぼう　*Nopperabo* (goblin with no facial features)

杯　Sake cup

狐　Fox

腹顔　*Bakemono* with a face for a stomach

41 狂歌百物語
きょうかひゃくものがたり
Kyoka Hyaku Monogatari

嘉永6年　1853

多くの人たちが詠んだ妖怪に関する狂歌を収録し、各丁に多色刷りで妖怪絵も描かれ、狂歌と絵を楽しめる趣向となっている。
This drawing shows a *kyoka* (comic tanka) relating to yokai about which many people have composed poems. Each page contains a full-color picture of a yokai. The books were designed for the enjoyment of both the *kyoka* and the yokai.

鎌鼬　*Kamaitachi* - weasel riding on a gust of wind

貍　*Nekomata* - demon cat

化鳥　*Bakedori* - shape-shifting bird

豆腐小僧　*Tofu-kozo* - child holding a tray with tofu on it

三ツ目　*Mitsume* - three-eyed hobgoblin

コラム Column 3

北斎百物語
Hokusai *Hyaku Monogatari*

江戸時代　葛飾北斎　260 × 190mm
Edo period, Katsushika Hokusai

百物語 こはだ小平次
間男に殺害された小幡小平次の幽霊が恨めしそうに出現。小平次の顔は骸骨として描かれている。
Kohada Koheiji - killed by his wife's lover, he returns in revenge to haunt the couple, his face depicted as a skull.

百物語 お岩さん
破れ提灯が髪を振り乱したお岩の顔となって不気味な雰囲気を醸し出している。提灯からは火が出て燃えあがろうとしている。提灯には「南無阿弥陀仏　俗名いわ女」とある。
O-Iwa-san - the vengeful ghost of Ms O-Iwa

江戸時代には、何人もが順番に怪談を話し、一話終わるごとに灯りを一本ずつ消していき、最後の一本が消えると怪異が起こるという言い伝えを実践して怖さを楽しむ、肝試しの百物語の集まりが流行した。さらに、各地のさまざまな怪異譚を集めた百物語本も人気を呼んだ。百物語とは必ずしも百話の怪談を話したり収録したりするのではなく、いくつもの怪異譚といった程度の意味である。百物語流行を背景に、葛飾北斎も「百物語」と題した「お岩さん」「こはだ小平次」「笑ひはんにゃ」「さらやしき」「しうねん」といった錦絵を制作している。北斎の百物語は人気を博し、納札、ポチ袋などにも転用され描かれていった。明治時代には落合芳幾によって再び錦絵化されているほどで、北斎の百物語が当時の人たちに強い印象を与えていたことをうかがうことができる。

During the Edo period there was a craze for *hyaku monogatari* (hundred-story) gatherings in which people tested their courage and got a thrill out of being scared witless by congregating in large numbers and taking turns to tell horror stories and put into practice the legend that if they extinguished one candle as each story finished, something strange would happen when the last flame had gone out. The "hundred stories" simply meant "a number of horror stories," not necessarily a hundred. Riding the wave of hundred tale popularity, Hokusai produced a number of prints thus titled including *O-Iwa-san*, *Kohada Koheiji*, the Laughing *Hannya*, *Sarayashiki* and *Shunen*. A huge hit, Hokusai's *hyaku monogatari* prints were appropriated for various items including votive tablets and the envelopes used for New Year cash gifts.

百物語 笑ひはんにゃ
右手に赤子の首を握り締めて笑いを浮かべる般若の大きく裂けた口元には赤子の血が滴っている。
The Laughing *Hannya* - holding the remains of her meal, a live infant

百物語 さらやしき
家宝の皿を割った腰元お菊は手討ちにされて井戸に投げ込まれ、幽霊として現れ皿の枚数を数えるという怪談を描いている。井戸から出現したお菊の幽霊の首は何枚もの皿で表現されている。
Sarayashiki - The story of O-Kiku and the Nine Plates

明治時代　落合芳幾
260 × 190mm
Meiji period, Ochiai Yoshiiku

百物語 しうねん
位牌の前には茶碗、横には供物が置かれ、それらにまとわりつく一匹の蛇という北斎ならではのイメージで「執念」という概念を表現している。
Shunen (Obsession)
Hokusai depicts the notion of obsession with snakes (the form vengeful spirits were believed to take) wrapped around a memorial tablet and bowl, customarily placed in the Buddhist altar for worship at home.

百もの語 おんりょう
明治時代に芳幾によって北斎の百物語と全く同じデザインの百物語が再びつくられた。左下には「北斎図」とあり、「芳幾模写」の落款がある。タイトルだけが変更されている。
Onryo from a Hundred Tales
In the Meiji period, Ochiai Yoshiiku produced a *hyaku monogatari* identical in design to Hokusai's. The painters' seals at the lower left read: "picture by Hokusai" and "copied by Yoshiiku." Only the title of the work differs.

113

江戸時代における木版印刷の発達は極彩色の錦絵を生み出していった。そのなかに妖怪を扱ったものも少なくない。源頼光の鬼や土蜘蛛退治、俵藤太の大百足退治といった伝説を描いたもの、いくつもの妖怪を描き「お化け尽くし」などのタイトルがつけられたおもちゃ絵、遊びのために制作された双六、さらには「お化け行灯」などのように切り抜いて立体物とするものなど、多種多様な妖怪錦絵が刷られていった。明治時代には新聞の妖怪記事を錦絵化した錦絵新聞と呼ばれるユニークなものも出されている。

妖怪を描くにあたって、妖怪の行列を画題にする場合のように大きな画面が必要なときには、何枚もの大錦サイズをつないで構成しているいっぽうで、1枚を上下に分けて2つのテーマを描くようなケースもあり、妖怪錦絵の世界が大きな広がりを有していたことが見てとれる。

The richly colored *nishiki-e* were a result of the development of woodblock printing technology in the Edo period. More than a few of them featured yokai as their subject matter. A wide variety of yokai *nishiki-e* were produced, from prints that depicted legends such as Minamoto no Yorimitsu vanquishing demons and the *tsuchigumo* and Tawara no Tota exterminating the giant centipede to the pictures on toys, *sugoroku*, and the three-dimensional games shown in Chapter 4. The Meiji period also brought what were known as a *nishiki-e shimbun* where articles in the newspaper about yokai were turned into *nishiki-e*.

The composition of the Night Parade of One Hundred Demons, which required a large picture plane was achieved by joining two or more large-format nishiki sheets together. There are also examples where a *nishiki-e* has been divided into upper and lower sections and have different subject-matter in each section.

3

極彩色の世界

Nishiki-e – A World of Gorgeous Color

42

後鳥羽法皇の夢中に現われたる妖怪図
ごとばほうおうのむちゅうにあらわれたるようかいず

Yokai Appearing in a Dream
to the Retired Emperor Go-Toba

慶応元年　秀斎　大判錦絵 6 枚続
1865, Shusai, series of six large-format *nishiki-e*

後鳥羽法皇が重い病に臥していたときに夢のなかに妖怪が現れて、夢からさめると病はすっかり回復していたという。この絵は夢に出てきた妖怪を描いたもの。
A yokai appears in a dream to the retired Emperor Go-Toba, bedridden with a serious illness. When he awakes from the dream, he has completely recovered.

43 和漢百物語
わかんひゃくものがたり

One Hundred Ghost Stories from China and Japan

慶応元年　月岡芳年　大判錦絵　26枚
1865, Tsukioka Yoshitoshi, twenty-six large-format *nishiki-e*

和漢百物語は全26図と目録からなる妖怪錦絵で、古くから伝わるさまざまな妖怪譚を芳年が描き、その絵に仮名垣魯文らが文章を添えている。

A series of yokai *nishiki-e* consisting of 26 drawings and an index. The yokai stories that have been handed down since ancient times were drawn by Tsukioka Yoshitoshi, and accompanying the drawings is text written by Kanagaki Robun and others.

和漢百物語

雷震

順風耳

千里眼

43

和漢百物語

楠多門丸正行

墨塘了古記

44 おもいつづら（新形三十六怪撰）
おもいつづら　しんけいさんじゅうろっかいせん

The Heavy Basket
(New Forms of the Thirty-six Ghosts)

明治 25 年　月岡芳年　大判錦絵
1892, Tsukioka Yoshitoshi, large format *nisiki-e*

新形三十六怪撰は芳年が晩年に描いた妖怪シリーズで、和漢百物語とともに彼の妖怪絵の代表作といえる。この絵はつづらから妖怪が出てくるという舌切り雀の物語の一場面を描いたもので、同様のテーマで和漢百物語でも取り上げている。

"New Forms of Thirty-six Ghosts" is a series of yokai pictures drawn by Tsukioka Yoshitoshi in his later years, considered to be, alongside "One Hundred Ghost Stories from China and Japan," his most noted yokai drawings.

45 源頼光土蜘蛛ヲ切ル図（新形三十六怪撰）
みなもとのよりみつつちぐもをきるず しんけいさんじゅうろっかいせん
Minamoto no Yorimitsu Slashes the *Tsuchigumo* (New Forms of the Thirty-six Ghosts)

明治25年　月岡芳年　大判錦絵
1892, Tsukioka Yoshitoshi, large format *nisiki-e*

47 昔ばなし舌切雀

むかしばなしししたきりすずめ

Tale of the Tongue-Cut Sparrow

元治元年　歌川芳盛　大判錦絵 3 枚続
1864, Utagawa Yoshimori, large-format *nishiki-e* triptych

上の「昔噺舌切雀」と基本的には同じ画面構成になっているが、タイトルや妖怪たちの姿、人物、背景などの配色、妖怪たちが黒一色で表現されていることなどが異なる。錦絵の異版を示す資料。
Although the composition of this triptych is similar to the above rendition, the yokai, the people and the use of color are different. Unlike the drawing above, the yokai here have been drawn in black and white. An example of a different version of the *nishiki-e*.

46

昔噺舌切雀
むかしばなししたきりすずめ

Tale of the Tongue-Cut Sparrow

元治元年　歌川芳盛　大判錦絵3枚続
1864, Utagawa Yoshimori, large-format *nishiki-e* triptych

つづらから妖怪たちが出てくるという舌切り雀の一場面がテーマ。右のつづらからは雀が飛び出し、左のつづらから出てきた妖怪たちと戦っている様子を描いている。

The subject of this triptych is the scene from the Tale of the Tongue-Cut Sparrow of the yokai emerging from the wicker basket. The sparrows have flown out of the wicker basket to the right and are shown battling the monsters that have emerged from the basket to the left.

48

佐藤正清四国征罰ノトキ小曽か部元親ノ本城ヲ責落ス折カラ不計深山ニ立入恠物退治ノ図

さとうまさきよしこくせいばつのときしょうそかべもとちかのほんじょうをせめおとすおりからはからずしんざんにたちいりかいぶつをたいじするのず

Sato Masakiyo Vanquishing Yokai at the Time of the Shikoku Conquest

文久2年　歌川芳虎　大判錦絵3枚続
1862, Utagawa Yoshitora, large-format *nishiki-e* triptych

佐藤正清（加藤清正の意）が四国征伐のときに遭遇した妖怪たちを退治する場面。中央の正清は槍で巨大な蝦蟇を退治している。正清の掲げる旗には「南無妙法蓮華経」「佐藤政清」と大書されている。背景は黒と灰色で闇を表現しているようだ。

The scene in which Sato Masakiyo (also known as Kato Kiyomasa) vanquishes the yokai he encounters at the time of the Shikoku Conquest. Masakiyo at the center of the drawing is slaying a gigantic toad (an apparition of a toad) with a spear. The black and grey background represents darkness.

49

佐藤正清四国征罰ノトキ
小曽か部元親ノ本城ヲ責
落ス折カラ不計深山ニ立
入怪物退治ノ図

さとうまさきよしこくせいばつのときしょうそかべもとちかのほんじょうを
せめおとすおりからはからずしんざんにたちいりかいぶつをたいじするのず

Sato Masakiyo Vanquishing Yokai at the Time of the Shikoku Conquest

文久 2 年　歌川芳虎　大判錦絵 3 枚続
1862, Utagawa Yoshitora, large-format *nishiki-e* triptych

上と基本的には同じ錦絵だが、正清が退治する蝦蟇がここでは狒々となり、旗に書かれた「佐藤政清」もなくなっている。
Although basically the same as the *nishiki-e* above, here the toad vanquished by Sato Masakiyo has been replaced with a baboon (an apparition of a monkey) and the flag showing the name Sato Masakiyo has disappeared.

50 源頼光公館土蜘蛛妖怪出現図

みなもとのよりみつこうのやかたつちぐもようかいしゅつげんのず

Tsuchigumo and Yokai Appear in Minamoto no Yorimitsu's Palace

江戸時代　歌川国長　大判錦絵3枚続　Edo period, Utagawa Kuninaga, large-format *nishiki-e* triptych

源頼光の館に出現した妖怪と土蜘蛛。頼光は伝家の宝刀で土蜘蛛を斬りつけた。左下には切り落とされた土蜘蛛の足がみえる。血の跡を辿って葛城山で土蜘蛛を発見した四天王は土蜘蛛退治を成功させる。

A *tsuchigumo* and other yokai appear in Minamoto no Yorimitsu's palace. Yorimitsu slashes at the spider with a sword. At the lower left can be seen one of the cut off legs of the spider. Following the trail of blood, Yorimitsu's four legendary retainers successfully vanquish the *tsuchigumo* they discovered at Mount Katsuragi.

51 道化百物かたり
どうけひゃくものかたり

Doke Hyaku Monogatari

慶応4年　大判錦絵3枚続　1868, large-format *nishiki-e* triptych

魚や獣の妖怪たちが集まって百物語を行なっており、背景の闇のなかにはさまざまな妖怪が出現している。このままでは蝋燭が消えずに夜が明けてしまい化物の世にならないと妖怪たちが困っているようだ。

Hyaku monogatari is a style of traditional Japanese ghost story-telling party. A few people gather together and after taking turns to tell a host of ghost stories, it is believed that real ghosts will appear. In this drawing, fish and animal yokai have gathered to tell ghost stories and a number of yokai have appeared amidst the darkness of the background. The yokai seem troubled by the fact that, if the candle goes on burning in this way until daybreak, there will be no world of ghosts tonight.

52 新案百鬼夜行（滑稽倭日史記）
しんあんひゃっきやぎょう こっけいやまとしき
New Design Night Parade of One Hundred Demons

明治 28 年　歌川芳幾　大判錦絵 9 枚続
1895, Utagawa Yoshiiku, series of nine large-format *nishiki-e*

52

134

53 源頼政鵺退治

みなもとのよりまさぬえたいじ

Minamoto no Yorimasa Vanquishing the *Nue*

江戸時代　歌川国芳　大判錦絵3枚続　Edo period, Utagawa Kuniyoshi, large-format *nishiki-e* triptych

鵺を弓の名手・源頼政が退治するという有名な話を題材にした錦絵は何種類も出されているが、これもその一つ。頼政の矢で射止められた鵺がものすごい形相で暗雲立ち込める空から落ちてくる場面をとらえている。鵺は、頭は猿、尾は蛇、手足は虎という想像上の生き物。

A *nishiki-e*, the subject of which is the famous story of master archer Minamoto no Yorimasa vanquishing a *nue*, a creature with a monkey's head, the tail of a snake and the limbs of a tiger. The *nue* has been pierced with Yorimasa's arrow and is falling from a sky filled with thunderclouds in spectacular fashion.

土蜘蛛に悩まされている頼光と碁を打ちながら寝ずの番をする四天王という設定の錦絵。しかし頼光は12代将軍徳川家慶、四天王に擬せられたのは沢瀉(おもだか)紋の着物を着た卜部季武が水野忠邦(沢瀉が家紋)など天保改革を推進した為政者たちで、上段に描かれた妖怪たちは改革の厳しい規制に恨みを持つ庶民、幕府の政策を風刺した内容だといわれている。この絵は庶民の大きな喝采を呼び、海賊版が出されるほど反響があった。

The drawing shows Yorimitsu, who has been plagued by the *tsuchigumo*, and his four legendary retainers, who are keeping vigil while playing an all-night game of *go*. In the drawing, Yorimitsu is said to represent Tokugawa Ieyoshi, the twelfth shogun; his four retainers - e.g. Urabe no Suetake wearing the kimono with the *omodaka* (three leaf arrowhead) crest said to represent Mizuno Tadakuni (whose family crest is the omodaka) - statesmen who were the force behind the Tenpo reforms; and the yokai in the upper section, the common folk resentful of the severe nature of the reforms. The drawing is a satirical look at the policies of the shogunate and was loudly applauded by the common folk. It was so popular that even pirated versions were published.

54 源頼光公館土蜘作妖怪図

みなもとのよりみつこうやかたつちぐもようかいをなすのず

Minamoto no Yorimitsu in his Palace with *Tsuchigumo* and Yokai

天保14年　歌川国芳　大判錦絵3枚続　1843, Utagawa Kuniyoshi, large-format *nishiki-e* triptych

55 土蜘蛛襲来図
つちぐもしゅうらいず

Attack on the *Tsuchigumo*

江戸時代　歌川国芳　大判錦絵3枚続　Edo period, Utagawa Kuniyoshi, large-format *nishiki-e* triptych

源頼光に襲いかかる土蜘蛛と退治しようとしている頼光と四天王。中央に主役の土蜘蛛と頼光を配し、左右に四天王を2人ずつ描いている。坂田金時は碁盤で妖怪を押さえ込んでいる。

Minamoto no Yorimitsu's four legendary retainers are trying to exterminate the *tsuchigumo* that is attacking Yorimitsu. The *tsuchigumo* and Yorimitsu have been placed at the center of the piece and to the left and to the right are two of the four retainers. Sakata Kintoki is holding the yokai down with a *go* board.

141

56

髪切の奇談
かみきりのきだん

The Strange Tale of the *Kamikiri*

慶応4年　歌川芳藤　大判錦絵2枚続
1868, Utagawa Yoshifuji, large-format *nishiki-e* diptych

「中外新聞」16号
Chugai Newspaper No. 16

慶応4年に発行された新聞記事にも、同年4月20日の出来事として東京の小川町歩兵屯所で起きた髪切りの怪異を報じている。
In an article in edition No. 16 of the Chugai Newspaper published in 1868, there was a report of an event occurring on 20 April in which a *kamikiri* ghost appeared at the Ogawa Infantry Quarters in Tokyo.

番町の武家屋敷で女中が夜中に厠に行くときに突然に真黒な化物に襲われて髪を切られたという事件を錦絵にしたもの。
A *nishiki-e* showing the event in which a maidservant in the house of a samurai in Bancho who got up to go to the toilet in the middle of the night was suddenly attacked by a black *bakemono* who cut off her hair.

極彩色の妖怪報道

コラム Column 4

Nishiki-e Newspapers

明治7（1874）年ころから10年代にかけてニュースを錦絵化した錦絵新聞、あるいは新聞錦絵と呼ばれるユニークな錦絵が多数刷られた。東京では落合芳幾が「東京日日新聞」の記事を錦絵化した「錦絵東京日日新聞」と月岡芳年が「郵便報知新聞」の記事を錦絵化した「錦絵郵便報知新聞」が中心で、大阪でも何種類もの錦絵新聞が出されている。大きさは大錦サイズ、大錦の半分のサイズなどがある。また、新聞をニュース源とせず、独自の記事を扱ったケースも見受けられる。錦絵新聞の内容は三面記事的なものが多く、妖怪や怪異の話題も少なからず取り上げられている。

浅草並木町で商売が不振となって借金を返済できずに店を手放した菓子屋の店主は死に、抵当として店を入手した者の病床に幽霊として毎夜現れてのどを絞めて苦しめる。

東京の元柳原町の梅村豊太郎宅に出現した三つ目の大入道は老狸が化けたものだった。

本所緑町から浅草まで人力車に乗った娘が茅場町あたりで姿を消したが、車賃として紅の紙で作られた幣が置いてあり、娘は疱瘡神であったに違いない。

From around 1874 for approximately ten years unique *nishiki-e shimbun*, or alternatively *shimbun nishiki-e* newspapers that presented the news in *nishiki-e* form were printed in large volumes. Content tended toward the page-three sensationalist sort, with stories of yokai and bizarre happenings featuring frequently.

郵便報知新聞 第六百六十三号

神田福田町なる大工棟梁何某が家に先っ頃怪しき事のありしは毎夜十二時とも覚しき頃らうらうと真黒なる一個の坊主がうろうろと女房が寝て居る側りようよらとわらはる所業の限り極め頬や口など甜るにその跡粘り胚き更壁するにのあり女房は毎夜のこととてゆるぎもつとせず眠りはやめらぐその夜は彼や出とだろうが来ると又もとのごとと其後絶へて沙汰あられる今に妖怪消滅せーするぶん

松林伯圓記

神田福田町の大工の家に毎夜のように真っ黒な坊主が現れて女房に不埒な行いを繰り返す。

秩父在の横瀬村に起こったポルターガイスト現象。
ついには大石も飛んできた。

57 狂斎百狂 どふけ百万遍
きょうさいひゃっきょう どうけひゃくまんべん

Doke Hyakumanben, from the Series 100 Ghosts by Kyosai

元治元年　河鍋狂斎　大判錦絵 3 枚続　1864, Kawanabe Kyosai, large-format *nishiki-e* triptych

中央に巨大な蛸が鎮座し、その周りで大数珠を回しながら妖怪たちが百万遍の念仏をしている。大蛸の足は5本しかなく、御本丸（ごほんまる）を意味し、将軍をトップとした徳川政権を表しているといわれ、幕末の政治動向を取り上げたものと考えられている。

Enshrined in the center is a giant octopus and as the large Buddhist prayer beads are passed around in a circle on the outside, the yokai are chanting one million prayers (*hyakumanben nenbutsu*) to Buddha. The *hyakumanben nenbutsu* is the belief that if a person can within seven days say one million prayers to Buddha, then he or she can achieve his or her goal. The octopus has only five tentacles signifying the *Gohonmaru* (Edo castle "*go hon*" also meaning "five legs") and said to represent the Tokugawa regime headed up by a shogun. It is believed that the drawing is picking up on political trends in the closing days of the Tokugawa shogunate.

58

相馬旧御所
そうまふるごしょ

Former Soma Imperial Palace

明治 26 年　楳堂小国政
大判錦絵 3 枚続
1893, Baido Kokunimasa,
large-format *nishiki-e* triptych

平将門の娘・滝夜叉姫は、平将門が滅ぼされた後も将門が内裏として使った相馬旧御所で妖術を駆使して抗した。そこへ大宅太郎光圀が退治に赴いている。この絵はそうした故事になぞらえて当時の政治状況を取り上げた作品だろう。
Taira no Masakado's daughter, Princess Takiyasha was, even after Masakado's downfall, using witchcraft at the Soma Palace which Masakado had used as an imperial palace. Oya no Taro Mitsukuni sets out to vanquish her. This drawing is an account of that and references the political situation of the time.

本所七不思議
The Seven Wonders of Honjo

本所七不思議
The Seven Wonders of Honjo
明治19年　岡田国輝　大判錦絵
1886, Okada Kuniteru, large-format *nishiki-e*

七つの不思議な話を集めた七不思議は全国各地にあり、江戸（東京）にも麹町七不思議、麻布七不思議などが伝えられているが、なかでももっとも有名なのが本所七不思議で、明治19年には岡田国輝（三代歌川国輝）が錦絵化している。国輝の本所七不思議シリーズは絵葉書として出されているくらいの人気があった。本所七不思議をテーマとした納札などもあり、本所七不思議を紹介した種々の書籍も出されている。本所七不思議の講談を速記した本も出ているほどだ。また、映画も制作されており、そのポスターも残されている。

"Seven wonders" collections of seven strange stories can be found all over Japan. The most famous of these are the Seven Wonders of Honjo, an area on the outskirts of Edo. As well as *nishiki-e* woodblock prints there are *nosatsu* votive tablets, various books about the Seven Wonders of Honjo (Honjo Nanafushigi, page 157), and even a shorthand version of Seven Wonders of Honjo storytelling. Numerous films with a Seven Wonders of Honjo theme have also been made, posters for which can still be found.

狸囃子

東七不思議之内　狸囃子

野久知橋葉撰

八束穂や狸もいなむ腹鼓神楽囃子に
透されて夜な夜な聞ゆる太鼓の音も
或は近く又は遠く釣り出され
ツイふらふらと此所彼所歩行疲れ
家ふ帰り前後を忘れ打臥ぬる
耳元近く啼ふ声ふ目覚て見れば
コワ不思議我が家ふからで露たる
柳下場の廣野か宵惣の高
新ぞ我ふから撮まれ
みも在りしなん人是えきふ狸子彼の
本所の廣野みち今ふ代ふも在らん

本所七不思議は江戸時代からよく知られた怪異譚だが、岡田国輝は明治19年にこのテーマを描いている。彼が描いたのは、夜回りが拍子木を打ち鳴らすとそれにあわせてカチカチと音がする「送撃柝（おくりひょうしぎ）」(#1)、殺された娘の恨みで片方にしか葉の生えない「片葉の芦」(#2)、釣り人が家路につこうとすると堀から「おいてけ」と声がしてビクの魚が消えている「置行堀（おいてけぼり）」(#3)、夜中に歩いていると前方に提灯の火が見えるが近づくと提灯は消えて真っ暗闇という「送提灯」(#4)、本所の広野で毎夜のように聞こえる「狸囃子」(#5)、割下水上の蕎麦屋の行灯は灯を点けないのに明るくて油は尽きることがないという「無灯蕎麦」(#6)、本所三笠町の旗本屋敷の天井から大足が出現して洗ってやると引っ込むという「足洗邸」(#7)、の7つだが、本所七不思議納札でもわかるように別の怪異が入っているケースもある。

The Seven Wonders of Honjo are:
#1: *Okuri Hyoshigi* (The Following Wooden Clappers): When the night watchman bangs his clappers a coinciding scratching sound is heard
#2: *Kataha no Ashi* (The One-side Reed): A reed that only grows leaves on one side, out of bitterness at the murder of a young woman
#3: *Oiteke Bori* (The "Leave it Behind" Moat): A fisherman starts for home when from the moat a voice says "Leave it behind!" and his fish disappear
#4: *Okuri Chochin* (The Sending-off Lantern): Walking at nighttime the light of a lantern is visible up ahead, but when one draws closer the light goes out, leaving it pitch black
#5: *Tanuki Bayashi* (The Music of the Racoon Dog): Heard almost nightly in the expanses of Honjo
#6: *Muto Soba* (The Unlit Soba Shop): The paper lantern outside a soba noodle shop built over a drainage canal burns brightly even when unlit, and never runs out of oil
#7: *Ashiarai Yashiki* (The Foot Washing Mansion): A huge foot appears from the ceiling of the home of a shogunal retainer, and withdraws if washed

怪談本所七不思議ポスター
Poster for the Movie *Kaidan Honjo Nanafushigi*

七不思議のなかでも広く知られている本所七不思議は第二次世界大戦以前にも映画化されているが、昭和32（1957）年には新東宝で映画化された。このポスターはそのときのもので、これ以外にも何種類ものポスターが刷られている。

本所七不思議講談本
Honjo Nanafushigi Books

本所七不思議は講談でも上演されているが、その内容は速記によって記録され書籍として刊行されている。書籍では挿絵や巻頭カラーページなどで読者の興味を引いている。

本所七ふしぎ納札
Honjo Nanafushigi Nosatsu

七不思議にタイトルをプラスした8枚の納札。狸が描かれたタイトル納札には「大正二(1913)年三月廿日出札」とあり、この納札が出された日が確認できる。出したのは築地大和屋と吉原いる安。七不思議の内容が国輝の錦絵と異なったものもある。また、「おいてけぼり」では河童が魚を盗んでいる図柄となっている。

江戸時代に描かれた妖怪はけっして恐ろしいものばかりではない。かわいらしい妖怪、キャラクター的妖怪、友達感覚的妖怪、まるでペットのような妖怪など、畏怖する存在とはかけ離れた妖怪たちの姿を数多く見ることができる。こうした妖怪は、遊びと密接な関連がある。遊びに妖怪が登場するということは江戸時代以降の特徴で、人々の妖怪観の変質を端的に示している。それを裏付けるものとして妖怪双六、妖怪カルタ、妖怪おもちゃ絵などがある。また、錦絵を指定どおりに切り取って立体化する立版古や、画面を変化させていくつもの妖怪を登場させる変わり絵などもつくられている。遊びのなかの妖怪は近代に入ってさらに発展し、メンコ、カードなどで子どもたちに親しまれている。

The yokai depicted in the Edo era were not always terrifying. On the contrary, there are many examples of yokai that do not conform to their fearsome image. Some of them are cute, funny and friendly-looking. These yokai are closely associated with the playing of games, a trend that started in the Edo period and demonstrates people's changing views of yokai. Representing that changed view were such things as yokai *sugoroku*, yokai playing cards and yokai picture toys and games. There were also the *tatebanko* (paper sculptures) in which *nishiki-e* were cut out according to specifications and made into three-dimensional objects and *kawari-e* in which yokai pictures on a sheet of paper would change when paper flaps were folded over. The association of yokai with playing games further developed in the modern era and they became known to children through such things as *menko* and playing cards.

4

妖怪遊び
Yokai Games

59 百種怪談妖物双六

むかしばなしばけものすごろく

One Hundred Kinds of Ghosts Stories – Yokai *Sugoroku*

安政 5 年　歌川芳員　480 × 700mm　1858, Utagawa Yoshikazu

振り出しは子どもたちが百物語をしている図である。坂東太郎の河童、玄海洋（玄界灘）の海坊主など、各地に伝わる妖怪を中心に紹介しているが、見越入道のように地域に直接関係しない一般的な妖怪も描かれている。

Sugoroku is a game in which the player rolls the die and proceeds to a square on the board according to the number on the die. The game starts from the bottom center square. The image shows children telling ghost stories. The drawings are principally of the various yokai that have populated Japan.

この双六が入っていた袋
The bag that holds the *sugoroku*.

60 大新板化物飛廻双六

だいしんばんばけものとびまわりすごろく

Daishinpan Bakemono Tobimawari-Sugoroku

明治時代　490 × 325mm　Meiji period

墨一色刷りの双六で描かれているのは器物の妖怪だけ。振り出しは大名行列の毛槍で、顔がサイコロになっている。版元は名古屋の井筒屋文助。井筒屋文助は右の「新版妖怪飛巡双六」の明治期版も刊行している。

A black-and-white printed *sugoroku* featuring exclusively household-implement yokai. The game starts from the daimyo's procession of the feather-topped spears with die for faces in the panel at the bottom right.

61 **新版妖怪飛巡双六**
しんぱんばけものとびまわりすごろく

Shinpan Bakemono Tobimawari-Sugoroku

江戸時代　412×300mm　Edo period

まったく同じ題名の双六が明治時代に名古屋の井筒屋文助から出されている。描かれた内容も上がり以外はすべて同じだが、版元は京都。紙質は異なっており、制作年代はこちらのほうが古く、井筒屋版はこの双六をベースにして制作されたものであろう。

A *sugoroku* board with exactly the same name was available in the Meiji period and except for the way in which the game ends, is the same in terms of content.

62

新板四天王
土蜘退治飛廻双六
しんぱんしてんのうつちぐもたいじとびまわりすごろく

Shinpan Shitenno Tsuchigumo Taiji Tobimawari-Sugoroku

江戸時代　310 × 460mm　Edo period

63

おばけ双六
おばけすごろく

Obake Sugoroku
明治時代以降　295 × 413mm
Meiji period and later

168

| 64 | **滑稽ばけもの双六**
こっけいばけものすごろく
Kokkei Bakemono Sugoroku
明治29年　田口米作　780 × 480mm　1896, Taguchi Beisaku | 65 | **化物つくし**
ばけものつくし
Bakemono Tsukushi
江戸時代　大判錦絵　Edo period, large-fomat *nishiki-e* |

66 しん版おばけ尽 しんばんおばけつくし *Shinpan Obake Tsukushi* 明治22年　荒川藤兵衛　大判錦絵 1889, Arakawa Tobe, large-format *nishiki-e*	**67** 新板おばけづくし しんばんおばけづくし *Shinpan Obake Tsukushi* 明治21年　歌川国利　大判錦絵 1888, Utagawa Kunitoshi, large-format *nishiki-e*

68 新板おどけばけ物つくし

しんぱんおどけばけものつくし

Shinpan Odoke Bakemono Tsukushi

江戸時代以降　長谷川小信　340 × 355mm
Edo period and later, Hasegawa Konobu

おもちゃ絵を得意とする芳藤の描いた小型の化物つくし絵。中段左には明治時代を象徴するようなランプのお化けも描かれている。
A small-scale *bakemono tskushi-e* drawn by Utagawa Yoshifuji, who specialized in painting toys. In the middle left panel is the "the monster of the lamp," symbolizing the Meiji period.

69 しん板お化けつくし
しんぱんおばけつくし
Shinpan Obake Tsukushi

明治時代　歌川芳藤　175 × 115mm
Meiji period, Utagawa Yoshifuji

70 ばけもの尽
ばけものづくし

Bakemono Tsukushi

明治時代　歌川国利　大判錦絵　Meiji period, Utagawa Kunitoshi, large-format *nishiki-e*

71 新板化物つくし

しんぱんばけものつくし

Shinpan Bakemono Tsukushi

万延元年　歌川重清　大判錦絵　1860, Utagawa Shigekiyo, large-format *nishiki-e*

72	新板化物づくし
	しんばんばけものづくし

Shinpan Bakemono Tsukushi

嘉永6年　歌川芳幾　大判錦絵
1853, Utagawa Yoshiiku, large-format *nishiki-e*

73	しんばんおばけづくし
	しんばんおばけづくし

Shinpan Obake Tsukushi

江戸時代　芳信　大判錦絵
Edo period, Yoshinobu, large-format *nishiki-e*

げんでんかむゆうぐらん　芳年戯画

75 妖物つくし
ばけものつくし

Bakemono Tsukushi

江戸時代　歌川国虎　280 × 110mm
Edo period, Utagawa Kunitora

74 化物つくし
ばけものつくし

Bakemono Tsukushi

江戸時代　168 × 88mm　Edo period

上段には押さえつけられた三つ目の妖怪が描かれている。
In the top row, a three-eyed yokai is being strangled.

しん版おばけのよめ入

しんぱんおばけのよめいり

Shinpan Obake no Yome-iri (Monsters' Wedding)

明治時代　歌川国麿　大判錦絵　Meiji period, Utagawa Kunimaro, large-fomat *nishiki-e*

Column 6 — 化物嫁入り絵巻
Bakemono Yome-iri Emaki (Monsters' wedding Picture scrolls)

化物の嫁入りを描いた絵巻はいくつか確認されているが、この絵巻もそのひとつ。現在確認されている絵巻には錦絵や草双紙にはある人の足を料理する場面などは描かれていない等々、若干の違いがみられるが、いずれも「化物の嫁入り」という面白く楽しい内容で、畏怖すべき存在としての妖怪とは対極にある。こうしたテーマで妖怪が描かれるのは江戸時代からのことである。

Several scrolls can be found depicting *bakemono* nuptials: this is one. The scrolls presently known to exist differ slightly to prints and picture books on the same theme, missing for example a scene depicting the cooking of a human foot, but all feature the fascinating, delightful subject of the "bakemono bride," in stark contrast to the usual image of yokai as creatures to be feared. Yokai only began to be depicted like this during the Edo period.

結婚式に備えて髪を結ってもらっている花嫁。
The bride having her hair done for the wedding ceremony.

「うしみつ屋」と書かれた茶屋で見合いをしているところ。男は湯飲み茶碗がひっくり返ったのも気がつかずに娘を夢中で見ている。いっぽうで娘は恥じらうように袖を口元にあてている。
Here we have the *omiai* arranged marriage gathering where the couple and their families formally meet for the first time, in this case at a teahouse apparently called Ushimitsuya. Mesmerized by the girl, the prospective groom is oblivious to his spilt tea. The girl for her part shyly covers her mouth with her sleeve.

77 四谷怪談立版古
よつやかいだんたてばんこ

Tatebanko Showing Scenes from the Yotsuya Kaidan

江戸時代　370×253mm　Edo period

This famous ghost story is about a woman with a half-swollen face named O-Iwa who, because she harbors a grudge, appears as a ghost.

立版古は、描かれたそれぞれのパーツを切り取り、糊づけして立体的場面をつくりあげるもので、これは四谷怪談をテーマとしている。糊しろなども指定されており、誰にでも作れる遊びでもあった。
A *tatebanko* is a toy in which the separate parts of a drawing are cut out and stuck together with glue to form a three-dimensional scene. As the area on which the glue is to be applied is indicated, *tatebanko* are easy enough for anyone to make.

怪談相馬内裏
かいだんそうまだいり

Ghost Stories of
the Soma Imperial Palace

江戸時代　落合芳幾　182 × 253mm
Edo period, Ochiai Yoshiiku

廃屋となった平将門の相馬内裏で妖術を使って骸骨や大蝦蟇などを出現させる将門の遺子滝夜叉姫を征伐しようと内裏にやって来た大宅太郎の戦いがテーマとなっている変わり絵。
A folding picture, the subject-matter of which is the battle of Oya no Taro who has arrived to vanquish a princess (upper right) who causes skeletons, giant toads and other things to appear with her witchcraft in the ruined Soma Imperial Palace.

79 歌舞伎座新狂言鵺退治組上ケ三枚続
かぶきざしんきょうげんぬえたいじくみあげさんまいつづき

Kabukiza Shinkyogen Nue Taiji Kumiage-sanmaitsuzuki

明治32年　393×265mm　1899

3枚の平面図を切り取って立体化するもので、歌舞伎座における鵺退治の公演を題材にしている。「出来上リ図」として完成図も描かれており、立体化したときの大きさも記されている。

A paper toy in which three flat drawings are turned into a three-dimensional drawing. The subject-matter of the drawings is a performance of the vanquishing of the *nue* in the Kabuki theatre. It also has a guide to what the completed drawing should look like and indicates the size of the completed three-dimensional drawing (page 184, top).

80 からくりお化け行灯
からくりおばけあんどん

Karakuri Obake Lantern

慶応4年　歌川芳藤　650 × 100mm　1868, Utagawa Yoshifuji

平面図を切り抜いて側面を折り返すと行灯の場面をさまざまに変えることができ、いくつもの妖怪が登場する。からくりお化け行灯は江戸時代から明治時代にかけて各種制作されているが、ラフカディオ・ハーンも愛好して手元に置いていたといわれる。
A game in which flat drawings are cut out and from them a lantern-shaped three-dimensional object is created. Various different scenes can be shown by turning over the paper.

81 からくりお化け行灯
からくりおばけあんどん
Karakuri Obake Lantern

明治時代　152 × 90mm　Meiji period

187

82 お化けカルタ
おばけかるた
Obake Karuta

明治時代以降　300×190mm　Meiji period and later

絵札と読み札が分割されずに印刷されたままの状態となっている。分割すると1枚1枚がかなり小さくなるので、実際にカルタ遊びに使われるためというよりもグッズとして制作されたのだろう。The sheet of printed cards shown here has not yet been cut into individual cards.

Karuta is a game played with a set of text cards and picture cards, and also a game deigned to help children memorize written characters. One player reads a text card and the first to find the matching picture card takes it. The person who takes the most cards is the winner.

83 お化けカルタ
おばけかるた
Obake Karuta

明治時代以降　60×45mm　Meiji period and later

カルタの読み札は必ずしも故事や言い伝えを忠実に記しているのではなく、絵札との関連で文章が作られているため、それぞれのカルタによって千差万別であり、このカルタの絵札と読み札もこのカルタ独自のものといえよう。

札の枠が左右、上下に大きくずれており、隣に印刷されていた札の画面が見えるものもあるほどなので、安価で販売されるために制作されたカルタと思われる。それぞれの札に描かれた妖怪の着彩もかなりずれていることがわかる。

84 お化けカルタ
おばけかるた
Obake Karuta

明治時代以降　50×36mm　Meiji period and later

神戸にあった紙芝居制作会社によって作られたもので、それぞれの紙芝居屋に貸し出されて広場や道路で子供たちに見せられた。
Kamishibai is a performance in which drawings that are based on a particular script are shown to the audience in sequence as the script is being read. The drawings were rented out to the *kamishibai* businesses and shown to children in a town square or by the road. There was no fee charged for watching the *kamishibai*. The objective of the showings was to sell sweets to the children.

85 紙芝居　怪談百物語の内　鬼火河岸 52 話
かみしばい　かいだんひゃくものがたりのうち　おにびかし 52 わ

Kamishibai: Onibi Riverside Stories, Hundred Ghost Stories #52

昭和時代　神港画劇協会　250 × 350mm　Showa period, Shinko Gageki Kyokai

86

紙芝居　怪談百物語の内
お千代鴉 19 話
かみしばい かいだんひゃくものがたりのうち おちよがらす 19 わ

Kamishibai: Ochiyogarasu,
Hundred Ghost Stories #19

昭和時代　神港画劇協会　250 × 350mm
Showa period, Shinko Gageki Kyokai

ケ、ケケッケ

作 淀川蛾と郎
構成 佐久井利江

5

神港画劇協会

生彩色 島森硯

「作・淀川蛾太郎　構成・佐久井利江　線・森島　色・彩生」とある。線と色の担当は「お千代鴉」や「鬼火河岸」と同じだが、作と構成の名前から紙芝居のストーリーは「怪談百物語」とは別の担当者によって作られたことがわかる。裏面にはインクでストーリーが書かれている。
The drawings were done by hand and the script of the play is written on the backs.

87　紙芝居　ケ、ケケッケ5話
かみしばい　け、けけっけ5わ

Kamishibai: Ke, kekekke #5

昭和時代　神港画劇協会　250 × 350mm　Showa period, Shinko Gageki Kyokai

88 神戸人形
こうべにんぎょう
Kobe Dolls

明治時代以降　Meiji period and later

❋神戸でおもに外国人向けに作られたからくり人形で、妖怪を題材にしたものも種々存在する。
Among the mechanical dolls made in Kobe principally for foreigners various kinds of yokai-themed dolls exist.

レバーを回すと首が伸び縮みして三味線を弾く。
If you turn the lever, its neck expands and contracts as it plays the shamisen.
120 × 70 × 50mm

箱の横にあるレバーを回転させると一つ目の傘のおばけが現われ、うちわを持ったおばけはびっくりして大きな口を開ける。
Turn the lever on the side of the box, and a one-eyed umbrella obake will appear and the fan-holding *obake* will open its mouth widely with astonishment.
100 × 70 × 70mm

196

レバーを回すと首が伸び、鐘の中の妖怪が隠れるのとともに、箱の前面から蛇が出たり入ったりする。
When you turn the lever, its neck expands, another yokai appears underneath the bell, and a snake goes in and out from the front of the box.
230 × 90 × 60mm

人力車風の乗り物を動かすと、坊主が木魚を叩いて首を伸び縮みさせる。
When you move the vehicle that resembles a rickshaw, the monk beats a wooden gong as his neck expands and contracts.
170 × 100 × 50mm

89

幻灯用種
ガラス
げんとうようたねがらす

Magic Lantern
Glass Slides

明治時代以降　82 × 82mm
Meiji period and later

明治時代に幻灯機が普及し、多くの人が楽しむようになったが、映し出されるものの中に妖怪を扱ったものもあり、その種ガラスも残されている。何枚かの種ガラスを連続して映してストーリー性を持たせたものから、1枚だけで妖怪を紹介したものまで、さまざまな種類があった。

Magic lanterns proliferated throughout Japan in the Meiji period and were now being enjoyed by many people. These glass slides contain pictures of various yokai.

199

90 お化けうつしえ大会
おばけうつしえたいかい
Obake Decals

昭和時代　440 × 180mm　Showa period

91 夜光おばけ
やこうおばけ
Glow-in-the-Dark *Obake* Stickers

昭和時代　231 × 96mm　Showa period

30セットが台紙に付けられている。1セット5円で駄菓子屋などで売られていた。1セットに18種類の妖怪があり、1点1点分割してこすることで絵を紙などに転写できる遊びグッズ。

The decals were torn off along the perforation and when rubbed, the drawing could be transferred to a piece of a paper or other object as a form of play.

92 光るお化けシール
ひかるおばけしーる

Glow-in-the-Dark *Obake* Stickers

昭和時代　440×340mm　Showa period

暗いところで光るシール。30セットが台紙に付けられており、1セット5円で駄菓子屋などで売られていた。

Stickers that glow in the dark. Sold at candy stores and other places.

1枚に1つの妖怪が描かれ、その横に点数も書かれているので、点数を競うゲームとしても使われたのだろう。
These cards were used for a points-based game. The points are shown next to the monster.

93

お化大会カード
おばけたいかいかーど

Obake Tourney Cards

昭和時代　47 × 31mm　Showa period

94 お化けカード
おばけかーど

Obake Cards

昭和時代　原画 140 × 90mm　カード 58 × 38mm
Showa period, Drawings 140 × 90mm, Cards 58 × 38mm

カード　Cards

原画　Drawings

1枚のカードに1点ずつ妖怪を描いたカード。原画をモノクロの写真で撮影したもの。原画も何点か残されているが、カードより大きなサイズである。
Cards made from black-and-white photographs of the original drawings. The drawings are of a larger size than the cards.

95

おもしろい新版
光るお化け
おもしろいしんぱんひかるおばけ

Omoshiroi Shinpan Hikaru Obake

昭和時代　118 × 80mm　Showa period

暗いところで光るシールが1束になっており、1枚ずつ袋に入っている。袋は古新聞を利用したもので、時代が垣間見られる。
The glow-in-the-dark sticker bags made from old newspapers give us a glimpse into this period in history.

裏面　Back

96

あぶりだしあそび
あぶりだしあそび

Invisible Ink Cards

昭和時代　156 × 120mm　Showa period

これも駄菓子屋などで売っていた遊びグッズで、1束になっており、1枚1枚を袋から取り出してあぶりだして遊んだ。
At the left is a form of play for the common folk, where a picture that is hidden appears when you take the cards out of the bag and warm them over a fire.

駄菓子屋などで売られていた30袋で1束の夜光シール。袋の中のシールが見本として表紙に貼られている。左は「くちさけ女」だ。
The sticker placed on the cover as an example shows a *"kuchisake (split-lipped) woman."* These stickers were sold in candy stores.

97

夜光おばけ／
連続エレキ夜光
おばけ
やこうおばけ／れんぞくえれきやこうおばけ

Two Types of Glow-in-the-Dark Stickers

昭和時代　120 × 80mm　Showa period

98

丸メンコ
まるめんこ

Menko

昭和時代　Showa period

妖怪が描かれた丸メンコにもさまざまな種類があり、大きさもまちまちだ。ジャンケンが描かれているカードはジャンケンカードとしても使われたものであろう。

Menko is a game that was all the rage among children in the Showa period. One player would place one the of *menko* cards (made from cardboard and printed with a pattern) on the ground and another player would throw down his card, attempting to flip or move the other first player's card in a certain way. If, successful he takes both cards. The cards that are printed with hands were also used for the game of rock-paper-scissors.

205

99 角メンコ
かくめんこ
Menko

昭和時代　75 × 40mm ほか　Showa period

メンコにもさまざまな妖怪が登場する。その種類も多いが、子どもの遊びに使われるので印刷は簡易なものばかりだ。
Created as playthings for children, these cards are cheaply printed.

妖怪映画ポスター
Yokai Movie Posters

コラム Column 7

昭和43（1968）年に大映から「妖怪百物語」と「妖怪大戦争」が封切られて人気を博し、翌年には「東海道お化け道中」が制作された。3作ともさまざまなポスターが刷られている。また、あちこちの映画館でも各種の妖怪映画が上映され、ポスターが出されている。
Various posters were printed for popular yokai movies such as Yokai *Hyaku Monogatari*, The Great Yokai War and *Tokaido Obake Dochu* (Ghosts Journey the Tokaido Highway).

納涼祭りポスター
Noryo Festival Posters

各地でイベントとしてお化け屋敷などが開催されてポスターが刷られているが、下のポスターもそうしたなかのひとつ。下段に開催日と開催場所が手書きされており、実際に貼られていたことがうかがわれる。
Posters advertising "chilling" summer festivals held locally throughout Japan that feature haunted houses and other "spine-tingling" fare.

妖怪はけっして絵巻や錦絵だけのなかに跋扈しているわけではない。もっと身近な存在としても浸透していた。印籠や煙草入れなどが落ちるのを防ぐ目的で象牙、金属、木などで作られた根付はわずか数センチほどの大きさだが、人、動植物をはじめ、さまざまな意匠が施されている。そこに妖怪も登場する。根付と紐でつながった印籠や煙草入れにも妖怪は登場するが、これらは武士から町人まで誰もが身につけるもので、日常生活のなかで触れ合っている妖怪グッズだ。さらには着物、帯、刺子半纏などにも妖怪がデザインされたものもあるくらいだ。

こうした生活のなかにひそむ妖怪の存在は江戸時代における妖怪文化の広がりを端的にあらわしているといえよう。

Yokai did not just appear in picture scrolls and *nishiki-e*. They had a closer relationship than that with human beings. *Netsuke* made from ivory, metal or wood and attached to medicine cases (*inro*) and tobacco pouches were only about a few centimeters in size and decorated in various ways such as with people, animals and plants. Yokai too came to decorate *netsuke, inro* and tobacco pouches and were worn by every type of person from mighty samurai to ordinary townsfolk. These things were the Edo period version of "yokai merchandise." Yokai also appeared on kimono, obi and quilted *hanten*.

5

生活のなかにひそむ妖怪

Yokai Lurking in Everyday Life

101 百鬼夜行図着物

ひゃっきやぎょうずきもの

Kimono with Night Parade
of One Hundred Demons Pattern

江戸時代以降　1360 × 1235mm　Edo period and later

213

102 妖怪図着物
ようかいずきもの
Kimono with Yokai Pattern

江戸時代以降　1340 × 1225mm　Edo period and later

103 異形賀茂祭図名古屋帯
いぎょうかもまつりずなごやおび

Nagoya Obi with Atypical Kamo Festival Pattern

江戸時代以降　3440 × 307mm　Edo period and later

妖怪が刺繍された箇所以外は無地で、締めることで妖怪の部分だけが見えるようになっている。
The obi is made from a plain cloth, the only color on the obi being the embroidered yokai, which fill the exposed surfaces of the obi when it is tied.

104

茨木童子図名古屋帯
いばらきどうじずなごやおび
Nagoya Obi with Ibaraki-doji Pattern

江戸時代以降　3440 × 300mm　Edo period and later

茨木童子は刺繍、背景の橋や雲と思しき図柄は染めによるデザインとなっており、締めると茨木童子が後ろ、橋の部分が前になる。
Ibaraki-doji is embroidered and the bridges, clouds and background pattern are dyed. When the obi is tied, Ibaraki-doji is shown the back and the bridge, at the front.

105 鵺図刺子半纏

ぬえずさしこばんてん

Quilted *Hanten* with *Nue* Pattern

明治時代以降　835 × 119mm　Meiji period or later

江戸時代から明治時代以降まで、組織された消防団が発展を遂げた。実際にこの分厚く重い半纏に水を含ませて、火事場で火消しをした。火事場では無地を表に、帰路につくときは裏返して派手な絵模様を背に着用したといわれる。

The concept of organized fire brigades developed during the Edo period and Meiji period in which there were many large fires. This thick, heavy *hanten* in fact held water, providing protection to firefighters at the site of the firefighting. The *hanten* was worn with the plain side on the outside while the fire was being fought and turned to the other side, which features a bright picture pattern on the back, as the firefighters returned from fighting the fire.

221

222

106 九尾の狐図刺子半纏

Quilted *Hanten* with Nine-Tailed Fox Pattern

江戸時代以降　990 × 1175mm　Edo period and later

暗雲がたなびき、稲妻が光る天空に出現した九尾の狐がデザインされている。九尾の狐は口から不気味な火を吐き出し、尾を逆立てている。刺子半纏の図柄デザイナーの名前は通常記されることはないが、ここでは「二代目北尾」なる名が瓢箪形の落款のように染め出されており、稀なケースといえよう。表は無地。

The pattern is of a nine-tailed fox that appears in the sky with a trail of dark clouds behind it and flashes of lightning. The nine-tailed fox spits an unearthly fire from its mouth and bristles its tails. The outside of the *hanten* is plain.

左からは幽霊、右からは骸骨が武士に襲いかかる構図で、怪談の一場面をデザインしたものだろうか。表は無地。
From the left comes a ghost and from the right a skeleton that are attacking a samurai. The pattern is possibly based on a scene from a ghost story. The outside of the *hanten* is plain.

107 幽霊骸骨図刺子半纏
ゆうれいがいこつずさしこばんてん

Quilted *Hanten* with Ghost and Skeleton Pattern

江戸時代以降　930 × 1250mm　Edo period and later

108 土蜘蛛退治図刺子半纏
つちぐもたいじずさしこばんてん
Quilted *Hanten* with *Tsuchigumo* Pattern

江戸時代以降　965 × 1195mm　Edo period and later

頼光の四天王が、潜む土蜘蛛を見つけて切りつける場面が描かれている。表は無地。
The outside of the *hanten* is plain.

109 土蜘蛛退治図刺子半纏
つちぐもたいじずさしこばんてん
Quilted *Hanten* with *Tsuchigumo* Pattern

江戸時代以降　970 × 1140mm　Edo period and later

源頼光の館に出没、怪異を起こして頼光を悩ませる土蜘蛛は絵巻や錦絵などに数多く描かれているが、刺子半纏にもさまざまなデザインで取り上げられている。この半纏もその一つで館を守る武士を凄い形相で襲う土蜘蛛。土蜘蛛が広げた糸や館の行灯なども描かれている。表は無地。

A *tsuchigumo* dramatically attacking a samurai guarding a palace. The design also shows the thread unfurled by the spider monster and the paper lantern of the palace. The outside of the *hanten* is plain.

228

110 妖怪図刺子半纏
ようかいずさしこばんてん
Yokai Quilted *Hanten*
江戸時代以降　950 × 1195mm　Edo period and later

中央の武士を襲う妖怪の姿がダイナミックに描かれている。
The yokai, which with wide-open mouth attacks the samurai at center stage, is depicted at the uppermost part of the *hanten*.

111 妖怪図刺子半纏
ようかいずしこばんてん
Yokai Quilted *Hanten*
江戸時代以降　930 × 1185mm　Edo period and later

土蜘蛛によって源頼光の館に出現した妖怪たち。土蜘蛛をテーマとした刺子半纏の多くは大きく土蜘蛛を描いているが、ここでは出現した妖怪にスポットを当ててデザインしている。表は一面に菱形が描かれている。

The yokai that through the doings of the *tsuchigumo* appear at the palace of Minamoto no Yorimitsu. The outside of the *hanten* is decorated with a diamond pattern.

231

112

土蜘蛛図刺子半纏
つちぐもずさしこばんてん

Quilted *Hanten* with *Tsuchigumo* Pattern

江戸時代以降　930 × 1190mm　Edo period and later

源頼光の館に現れた土蜘蛛のデザイン。左右の袖いっぱいに蜘蛛の巣が張られ、その中央に土蜘蛛がいる。表は無地。
A pattern featuring a *tsuchigumo* making an appearance at the palace of Minamoto no Yorimitsu. The spider's web extends across both the left and right sleeves, with the spider monster in the center. The outside of the *hanten* is plain.

113 九尾の狐図刺子頭巾
きゅうびのきつねずさしこずきん
Quilted Hood with Nine-Tailed Fox Pattern
江戸時代以降　690 × 730mm　Edo period and later

尾を振り乱しながら走り抜ける九尾の狐。その周囲にデザインされているのは黒雲で、天空を走っているのだろう。表は無地。
A nine-tailed fox runs through the scene splaying its tails. Around him are dark clouds so he is possibly running across the sky. The outside of the hood is plain.

114 舌切り雀図皿
しただきりすずめずざら

Plate with Tongue-Cut Sparrow Pattern

明治時代以降　高さ 46 × 直径 310mm
Meiji period and later, Depth 46 × Diameter 310mm

舌切り雀の話のデザイン。貪欲婆がつづらを開けると中から妖怪が出てくるという有名な場面。つづらの横には轆轤首などいくつもの妖怪が飛び出して驚愕する婆の姿もある。
When the greedy old woman opens her wicker basket, yokai jump out. From the side of the wicker basket, long-necked *rokurokubi* and other yokai stick their heads out, scaring the old woman out of her wits.

3つの図柄がデザインされているなかのひとつが妖怪図。草むらからヌーと出てきた妖怪は大きな口をあけているようにも、舌を出しているようにもみえる不気味な姿だ。足はなく、手は幽霊のように垂らしているようにもみえる。
One of the three patterns on the plate features a yokai. The yokai that has emerged from a clump of bushes is an unearthly creature with its wide-open mouth and what looks like its tongue sticking out. It has no legs and its arms seem to droop like those of a ghost.

115
妖怪図古伊万里皿
ようかいずこいまりざら
Old Imari Plate with Yokai Pattern

江戸時代　高さ29 × 直径250mm
Edo period, Depth 29 × Diameter 250mm

116 百鬼夜行図皿

ひゃっきやぎょうずざら

Plate with Night Parade of
One Hundred Demons Pattern

明治時代以降　高さ29×直径180mm
Meiji period and later, Depth 29 × Diameter 180mm

百鬼夜行絵巻では前足だけの真っ赤な妖怪が、ここでは蛙のような色柄になっている。その左の熊手を持つのは麒麟で、絵巻では蟻の妖怪といっしょになって件の妖怪を退治しようとしているが、ここではこの妖怪に左足をかまれて驚いているようだ。

A scene from a Night Parade of One Hundred Demons Picture Scroll. The yokai that only has front legs and is bright red in the picture scroll here has the color patterns of a frog. To its left, a qilin is holding a rake. In the picture scroll, the qilin joins forces with ant yokai to vanquish the frog-like yokai, but here he appears to be alarmed that the frog is biting his left leg.

六角皿の中央に泳ぐ河童が描かれている。背中には小さな甲羅が、指の間には水かきがあり、手足には毛が生えているようだ。顔からは長いひげが伸び、鯰のような風貌をしている。

A kappa swimming in the center of hexagonal plate. It has a small shell on its back, webs between its fingers, hair growing from its arms and legs, and a long beard hangs from its face. It resembles a catfish.

117 河童図古伊万里皿
かっぱずこいまりざら

Old Imari Plate with *Kappa* Pattern

江戸時代　高さ 85 ×直径 780mm　Edo period, Depth 85 × Diameter 780mm

118 幻獣図古伊万里鉢
げんじゅうずこいまりばち
Old Imari Bowl with Mysterious Creature Pattern

江戸時代　高さ 13.4 × 直径 350mm　Edo period, Depth 13.4 × Diameter 350mm

さまざまな格好をした緑色の幻獣がいくつも描かれ、その周囲には赤や青の雲がたなびく。鉢の外側も同様のデザイン。

The bowl features mysterious green creatures in various guises. Red and blue clouds trail behind around them. The outside of the bowl is decorated with the same design.

119 妖怪図京焼鉢
ようかいずきょうやきばち

Kyoto-ware Ceramic Bowl with Yokai Pattern

江戸時代以降　高さ29 ×直径120mm
Edo period and later, Depth 29 × Diameter120mm

手前に一つ目の妖怪、中央に着物を着た老婆のような妖怪、奥に三つ目の妖怪がデザインされている。外側には花が描かれている。

In the foreground is a one-eyed yokai, the center a yokai resembling an old woman wearing a kimono, and at the back, a three-eyed yokai. The outside of the bowl has a floral pattern.

120 釣狐図明石焼徳利
つりぎつねずあかしやきとっくり
Akashi-ware Sake Bottle with Fox-trapping Pattern
江戸時代　140 × 50mm　Edo period

釣狐は狐を捕らえる罠のこと。この罠に捕らえられた狐一族が猟師に恨みを持ち、猟師の伯父の僧侶（白蔵主）に化けて、釣狐の殺生を諭す話はよく知られている。
A *tsurigitsune* is a trap for catching foxes. Hakuzosu – the story of a fox whose family having been caught in these traps, harbored a grudge against the trapper, and disguised as the trapper's uncle, Hakuzosu, visits the trapper and admonishes him for the killing foxes – is a well-known one.

121 化け猫図花瓶
ばけねこずかびん
Flower Vase with *Bakeneko* Pattern
明治時代以降　225 × 100mm　Meiji period and later

猫の怪異や化け猫の話はいくつも伝えられており、錦絵などにも描かれている。この花瓶にデザインされた化け猫にまつわるストーリーがあるかは不明である。
There have been many images of yokai cats and *bakeneko* (shape-shifting cats) depicted over the years, in *nishiki-e* and on objects.

122 白蔵主像信楽焼
はくぞうすぞうしがらきやき
Hakuzosu-shaped Shigaraki-ware

江戸時代　143 × 80mm　Edo period

白蔵主という僧侶を食い殺して白蔵主に化けていた狐が、ついには犬にその正体を見破られて食い殺されるという有名な伝説を元にしたもの。狐が化けた白蔵主の絵は数多く描かれているが、ここでは白蔵主を焼物として制作している。

Based on the famous legend of a fox who devoured a monk called Hakuzosu, then turned himself into Hakuzosu, and was devoured by a dog who discovered who it really was.

123 白蔵主土人形
はくぞうすつちにんぎょう
Hakuzosu (Fox Spirit) Clay Figure

江戸時代以降　110 × 50mm　Edo period and later

狐が僧侶に化けた白蔵主の話。土人形に彩色を施している。同様のテーマで、絵だけでなく根付なども作られている。

A painted on a clay figure depicting on the popular Hakuzosu.

124 **狐団扇絵**
きつねうちわえ
Procession Across the Bridge Led by Foxes (Flat Fan Picture)
江戸時代　225 × 290mm　Edo period

125

九尾の狐扇子
きゅうびのきつねせんす
Nine-Tailed Fox Folding Fan

明治時代以降　170 × 355mm
Meiji period and later

243

126 化物団扇
ばけものうちわ
Bakemono Flat Fans

明治時代以降　374.4 × 216mm　Meiji period and later

河童の怪
Kappa

小夜衣岬紙 小夜衣
Sayogoromo

化ケ地蔵
Bakejizo

127 烏天狗図鏡蓋根付
からすてんぐずかがみぶたねつけ
Crow *Tengu Kagamibuta* (Mirror-lid) *Netsuke*

江戸時代以降　金属、象牙　直径 46mm
Edo period and later, Metal and ivory, Diameter 46mm

※鏡蓋根付は鏡の蓋にする根付で中央の円形金属部分にデザインがある。
Kagamibuta netsuke are modeled on a mirror cover, with a design worked on the round metal center.

原寸大
Actual size

原寸大
Actual size

128 九尾狐図饅頭根付
きゅうびのきつねずまんじゅうねつけ
Nine-Tailed Fox *Manju Netsuke*

江戸時代　木製　直径 47mm
Edo period, Wood, Diameter 47mm

※饅頭根付は饅頭のような形の根付。
Manju netsuke are shaped like a traditional Japanese *manju* cake.

129 土蜘蛛図鏡蓋根付
つちぐもずかがみぶたねつけ

Tsuchigumo Kagamibuta Netsuke

江戸時代以降　金属、象牙　直径 45mm
Edo period and later, Metal and ivory, Diameter 45mm

原寸大
Actual size

130 河童図鏡蓋根付
かっぱずかがみぶたねつけ

Kappa Kagamibuta Netsuke

江戸時代以降　金属、象牙　直径 53mm
Edo period and later, Metal and ivory, Diameter 53mm

この根付には鎖もついている。
This *netsuke* also has a chain.

原寸大
Actual size

※根付は煙草入や印籠などを帯にはさんで腰に下げるときに、落ちないように紐の端につけるもので数センチほどの大きさ。素材は象牙、木、獣の骨、金属、焼物などさまざまで、多種多様なデザインが施されている。そのなかには妖怪を題材としたものも数多い。

Netsuke are attached to the end of the cord people use to insert the likes of tobacco pouches and medicine boxes into their obi sashes, to prevent these items falling off when hung from the waist. Made from a variety of materials including ivory, wood, animal bone, metal and ceramics, they cram wonderfully diverse designs into just a few centimeters. Many also have yokai themes.

131 白沢 根付
はくたく ねつけ
Hakutaku Netsuke

江戸時代以降　象牙　40×45mm
Edo period and later, Ivory

原寸大
Actual size

132 魚を掴む河童 根付
さかなをつかむかっぱ ねつけ
Kappa Grasping a Fish *Netsuke*

江戸時代以降　金属、象牙　直径53mm
Edo period and later, Metal and ivory, Diameter 53mm

目が出たり引っ込んだりする細工がされている。
The kappa's eyes are made to move in and out.

原寸大
Actual size

133 烏天狗 根付
からすてんぐ ねつけ
Crow *Tengu Netsuke*

江戸時代以降　象牙　30×40mm
Edo period and later, Ivory

原寸大
Actual size

134 人魚　根付
にんぎょ　ねつけ
Mermaid Netsuke

明治時代以降　象牙　78 × 37mm
Meiji period and later, Ivory

135 白蔵主　根付
はくぞうす　ねつけ
Hakuzosu (Fox Spirit) *netsuke*

江戸時代以降　獣骨
62.7 × 18mm
Edo period and later, Animal bone

原寸大
Actual size

136 烏天狗　根付
からすてんぐ　ねつけ
Crow *Tengu* Netsuke

江戸時代以降　象牙　高さ 13.6 ×幅 44mm
Edo period and later, Ivory, H:13.6 × W:44mm

原寸大
Actual size

249

137

幽霊図板根付
ゆうれいずいたねつけ
Ghost *Ita-Netsuke*

江戸時代　象牙　126 × 50mm
Edo period, Ivory

❋板根付は板状の根付。
Ita-netsuke are flat, board-shaped *netsuke*.

裏　Back

「卍老人百気夜行狂画之内図」とある。

250

139

鬼図小柄
おにずこづか

Demon Knife Handle

江戸時代　金属　99 × 14.6mm
Edo period, Metal

138

茨木童子図小柄
いばらきどうじずこづか

Ibaraki-doji (Demon Child) Knife Handle

江戸時代　金属　92.5 × 14.8mm
Edo period, Metal

140

鬼図小柄
おにずこづか

Demon Knife Handle

江戸時代　金属　98 × 12.2mm
Edo period, Metal

251

141 茨木童子図小柄
いばらきどうじずこづか
Ibaraki-doji (Demon Child) Knife Handle

江戸時代　金属　100 × 15mm
Edo period, Metal

142 狐嫁入図小柄
きつねよめいりずこづか
Fox Bride Knife Handle

江戸時代　金属　14.8 × 101.6mm
Edo period, Metal

※鍔は、刀の柄と刀身との間に挟んで、柄を握る手を防護する部具。
The sword guard or *tsuba* is a piece placed between sword hilt and blade to protect the hand holding the hilt.

143

釣り狐図鍔
つりぎつねずつば
Tsurigitsune (Trapping of the Fox) Sword Guard

江戸時代　金属　68 × 66mm
Edo period, Metal

144

鬼図鍔
おにずつば

Demon Sword Guard

江戸時代以降　金属　84 × 77mm
Edo period and later, Metal

145

鬼図鍔
おにずつば

Demon Sword Guard

江戸時代以降　金属　79 × 63mm
Edo period and later, Metal

146

轆轤首図鍔
ろくろくびずつば

Rokurokubi Sword Guard

江戸時代以降　金属　直径 80mm
Edo period and later, Metal, Diameter 80mm

147

河童図鍔
かっぱずつば

Kappa Sword Guard

江戸時代以降　金属　84 × 77mm
Edo period and later, Metal

148 酒呑童子図煙管
しゅてんどうじずきせる
Shuten-doji Pipe

江戸時代以降　金属、竹　216 × 32mm
Edo period and later, Metal and bamboo

中央のラウ（竹）を挟んで、上には源頼光によって斬り落とされた酒呑童子の首、下には酒呑童子を見上げる頼光をデザイン。
Above the central stem of the pipe, a design featuring the head of Shuten-doji severed by Minamoto no Yorimitsu, and below, Yorimitsu looking up at Shuten-doji.

149 酒呑童子図煙草入れ
しゅてんどうじずたばこいれ
Shuten-doji Tobacco Pouch

江戸時代以降　革　75 × 140mm　Edo period and later, Leather

斬り落とされた酒呑童子の首と源頼光の図。
Illustration showing the beheaded Shuten-doji and Minamoto no Yorimitsu.

❋印籠とは、帯などに下げて持ち歩くポータブルな薬入れで、蒔絵などで図柄が描かれた。
Inro were portable medicine containers, often hung from the obi, and featuring designs in *maki-e* etc.

150

傘お化け図印籠
かさおばけずいんろう

Kasa-Obake (Umbrella Monster) *inro*

江戸時代以降　111.5 × 71mm
Edo period and later

印籠の先には根付がついている。
The *inro* has a *netsuke* attached to the end.

151

舌切り雀図印籠
したきりすずめずいんろう

Inro with Illustration from the Tale of the Tongue-Cut Sparrow

江戸時代以降　77.35 × 54.6mm
Edo period and later

表にはつづらから出てきた化物たち、裏面には化物の出現に驚いて顔を伏せる老婆が描かれている。
On the front, *bakemono* emerging from the basket, on the back, the old woman cowering in surprise.

裏　Back

神社や寺院に詣でた人が社殿などに貼る千社札、寺社に参詣した記念に納める納札、祈願や報謝のために寺社に奉納する絵馬など、祈りや信仰に関わる妖怪資料が存在する。千社札や納札は趣味として作り、同好の士が集まって交換したり、見せ合ったりするような会も開かれるほどで、妖怪もさまざまな種類が存在するが、収集対象としてストックブックなどに貼り込まれているケースも多々見られる。

絵馬は実際に奉納されたものと、お土産やおもちゃ的性格を持つものとがあるが、どちらにも妖怪が描かれたものが存在する。妖怪が描かれた千社札、納札、絵馬は現在も作られているが、そのほとんどが趣味的なものとなっている。

いっぽう、現在でも祈りの対象として制作されているものもある。牛のような格好で一本足の妖怪夔（き）のお札は雷除けとして信仰を集めている。江戸時代から夔は雷除けとして信じられており、その図を掛軸として所有して雷のときに飾って落雷を避けていたことが知られている。

In Japan, there are various examples of the association of yokai with prayer and religious faith. There are the *senjafuda* slips of paper posted by pilgrims on the pillars of shrines and temples, *nosatsu* votive tablets offered at shrines, and wish-bearing *ema* wooden pictures originally of horses. Eventually, *senjafuda* and *nosatsu* became less associated with religious faith and people began making them as a hobby. Like-minded people would even gather together for parties where they would exchange the *senjafuda* and *nosatsu* or show them to each other. There are also examples of where people have collected them and stuck them into scrapbooks.

Ema were not only for dedicating to shrines but also served as souvenirs and toys, both of which have depicted yokai. These *senjafuda*, *nosatsu* and *ema* are still produced today, most of them as part of a hobby.

However, there are also those that are produced as prayer items. Since the Edo period it was believed that an *ofuda* (an amulet from a Shinto shrine) showing a *ki* (kui), a one-legged yokai that looks like a cow, could protect people from lightning, and that hanging a picture of the *ki* in the form of a hanging scroll in a house would protect it from being struck by lightning.

6

祈りと妖怪
Yokai and Prayer

152 夜興納札怪異
やきょうのうさつかいい
Yakyo Nosatsu Kaii

明治時代以降　154 × 50mm
Meiji period and later

葛の葉　The fox Kuzunoha

安倍保名に助けられた白狐が恩返しのために化けて現れ、やがて恋仲となり子ども（のちの安倍晴明）をもうける。

岡崎の猫　The *bakeneko* of Okazaki

岡崎の古寺にすみついた、老婆に化けた猫の妖怪。旅人を襲う。

頼豪（らいごう）　The monk Raigo

天台宗の僧。比叡山の不当な扱いに抗議し断食して命を絶ち、鼠に変じて比叡山の経文を食い荒らした。

怪異をテーマとした納札で、さまざまな怪異や妖怪を取り上げている。
Nosatsu (votive cards) on spooky themes, featuring various strange tales and yokai.

153 百鬼夜行納札
ひゃっきやぎょうのうさつ

Nosatsu Featuring Night Parade of One Hundred Demons

明治時代以降　150×96mm　Meiji period and later

真珠庵系の百鬼夜行絵巻に描かれたお馴染みの妖怪をはじめ、灯篭、徳利などの新たな妖怪をも描いている。それぞれの妖怪の名前は書かれていない。
Featuring familiar yokai found in Shinjuan-style picture scrolls of the Night Parade of One Hundred Demons, as well as new yokai including lanterns and sake bottles.

154 お化け納札
おばけのうさつ

Obake Nosatsu

昭和時代　180 × 54mm　Showa period

障子に映った影絵の妖怪、多色刷りの妖怪など別種の納札が貼り込み帖に貼られている。
Book containing different *nosatsu* including shadow picture yokai on paper screens and yokai printed in multiple colors.

155 化物尽くし納札
ばけものつくしのうさつ

Bakemono-tsukushi Nosatsu

昭和時代　176 × 118mm　Showa period

器物の妖怪を中央左右に配して、上下に納札会参加者たちの名前を記すというユニークなスタイルの納札。
Unique *nosatsu* featuring kitchen utensil yokai at center, right and left, and at top and bottom, space to write the names of those offering the cards.

156 酒呑童子図絵馬
しゅてんどうじずえま

Ema of Shuten-doji

江戸時代以降　655 × 455mm　Edo period and later

斬り落とされても頭が源頼光を襲う酒呑童子。
Wooden picture showing a beheaded Shuten-doji still attacking Minamoto no Yorimitsu.

大木の横を通る狐の嫁入り行列が描かれ、左下に奉納者の名前が書かれている。
A fox's bridal procession passing by a large tree. The name of the person making the offering is written at bottom left.

157 狐の嫁入図絵馬
きつねのよめいりずえま

Ema Featuring Fox Bride Illustration

明治時代以降　335 × 455mm　Meiji period and later

158

鵺退治図絵馬
ぬえたいじずえま

Ema of Vanquishing *Nue*

江戸時代以降　676.5 × 984mm
Edo period and later

源頼政による鵺退治を描いた大型絵馬。左下に後年に貼られた紙片がある。
At bottom left is a piece of paper stuck on at a later date.

159

鵺図絵馬
ぬえずえま

Ema of *Nue*

明治時代以降　590 × 870mm
Meiji period and later

中央に大きく鵺が描かれ、背景に黒雲と稲妻がみえる。
The image of the *nue* dominates the frame, set against a backdrop of thunderclouds and lightning.

3者の鬼がドンチャン騒ぎをしている図。右下に奉納者の名前が書かれている。
Three demons are making a great din. The name of the person dedicating the picture is written at bottom right.

160 鬼図絵馬
おにずえま

Ema Featuring Demons

明治時代以降　241 × 357mm　Meiji period and later

161

夔図
きず

Kui

江戸時代　1525 × 550mm　Edo period

夔は中国に伝わる牛のような顔つきの一本足の幻獣で、雷除けとして信仰された。甲斐国の岡神社に夔の木彫像が伝わっており、江戸時代にこの像をもとに木版印刷による夔図が何種類も刷られて軸装されるなどして雷除けとして使われた。

The *kui* (in Japanese, *ki*) is an imaginary one-legged beast with the face of an ox, found in Chinese mythology. It was worshiped to ward off thunderstorms.

おしまい

作品解説
Description of Works

p26

④

百鬼夜行絵巻
Night Parade of One Hundred Demons Picture Scroll

真珠庵系の絵巻に別系統の百鬼夜行絵巻を合体させた図柄で、図にも風車で遊ぶ一つ目の子どもの妖怪や刺股を握った腹にも目のある妖怪などが真珠庵系の絵巻に登場する妖怪たちの行列のなかに加えられている。この絵巻の最後は太陽が昇り明るくなってきたために四散する妖怪たちが描かれている。

A one-eyed child yokai playing with a pinwheel, a yokai with an eye in his stomach clutching a two-pronged pike, and other kinds of yokai have been incorporated into the procession of yokai that appear in this Shinjuan-style picture scroll. At the end of the scroll, the yokai have started to scatter as the sun rises in the sky.

p30

⑤

百鬼夜行絵巻
Night Parade of One Hundred Demons Picture Scroll

竜頭の亀に乗る蛙、臼の妖怪を乗せた車を引く動物の妖怪、五輪塔の妖怪などが登場し、最後は暗雲が広く天を覆っている場面で終わる。この系統の絵巻と真珠庵系の絵巻が合体した絵巻も存在しており、百鬼夜行絵巻の成立と広がりを知るうえでも貴重な資料といえよう。

This picture scroll features a frog that has climbed on top of a turtle with a dragon's head, an animal yokai pulling a cart carrying a mortar yokai, and a five-stone pagoda yokai. The story ends with dark clouds spreading to cover the sky.

p32

⑥

百鬼夜行図巻
Night Parade of One Hundred Demons Picture Scroll

狩野宴信が描いた独自の百鬼夜行の世界。古びた廃屋を一夜の宿とした旅の僧が体験した怪異を描いている。庭先では猫が宴会の最中で夢中で踊り狂い、別の場面では闇から鬼の顔が浮かび、檜扇や琴が跋扈したり、屏風に描かれた南蛮人たちの行列が座敷へと飛び出して歩を進める姿などが登場する。
この絵巻のもっとも印象的な場面は大広間に火焔が舞い、囲炉裏からは印を結んだ巨大な手が現れ、鞍や湯桶の妖怪が集まって来たところをお歯黒の大きな女の顔が襖を開けて覗いている不気味な情景といえよう。やがて日が昇りはじめて妖怪たちの饗宴は終焉する。
宴信は延享2（1745）年に春信から家督を相続し、幕府が朝鮮に贈る屏風を描くなどして宝暦11（1761）年に没している。

A unique Night Parade of One Hundred Demons world depicted by the painter Kano Enshin. The subject of the painting is the spooky experiences of a monk who slept overnight in an old abandoned house. In one scene, we see a cat in a garden dancing about in the middle of a banquet. In another, the head of a demon pokes out of the darkness, wooden fans and a Japanese zither are running wild, and (not seen here) a procession of *nanbanjin* (Europeans who visited Japan in the 16th and 17th centuries) painted on a folding screen burst into the tatami-matted room and continue their procession.
The most memorable of all scenes in this picture scroll is the one in which we see a flames dancing in a hall, a giant hand making a Buddhist-statue-like gesture emerging from a hearth, and the sinister face of a woman with black-painted teeth peering through fusuma doors ajar at the saddle, hot-water pot and other yokai who have gathered together. The sun eventually starts to rise and the yokai's banquet is coming to an end.

p34

⑦

化け物づくし絵巻
Bakemono-Zukushi Picture Scroll
この絵巻に収録された12種類の妖怪のうち、「狐火」以外はそれまで未見の妖怪で、どのような特徴の妖怪かも不詳。妖怪の名前にルビがあるのも一般的に知られていなかった妖怪だったからと思われる。数多くの妖怪のなかに知られていない妖怪がいくつか描かれた絵巻は散見するが、未見の妖怪だけが登場する絵巻の存在は、ポピュラーな妖怪図鑑的絵巻とは別系統の流れがあったことをうかがわせる。
An illustrated-reference-book-like yokai picture scroll featuring some lesser-known yokai.

p36

⑧

化け物づくし絵巻
Bakemono-Zukushi Picture Scroll
9場面からなる妖怪図鑑的の絵巻。「ぬっぺっぽう」や「ぬらりひょん」といった鳥山石燕の『画図百鬼夜行』でおなじみの妖怪も収録されているが、2つの妖怪の描かれ方には大きな違いがある。「ぬっぺっぽう」には背景が描かれていないが、「ぬらりひょん」には背景がある。『画図百鬼夜行』はすべての妖怪に背景が描かれており、この絵巻の「ぬらりひょん」は『画図百鬼夜行』の描き方を踏襲している。他の場面も背景が描かれているものが多く、一般的な妖怪図鑑的絵巻が妖怪だけを描いているのと比較して特異な絵巻といえるが、背景の描かれた場面のものは版本などから転載されており、ストーリー性を想像させる趣向だろう。9場面の妖怪がどのような基準で収録されたかは不明だが、背景の描かれた妖怪と描かれていない妖怪の混在などの解明は今後の課題だ。
An illustrated-reference-book-like yokai picture scroll with nine scenes. The scroll also features *nuppeppo* and *nurarihyon*, the well-known yokai from the famous *Gazu Hyakki Yagyo* (Illustrated Night Parade of One Hundred Demons) by Toriyama Sekien. The way in which each of the two yokai has been drawn is markedly different. There is no background to *nuppeppo*, but there is to Nurarihyon. In *Gazu Hyakki Yagyo*, a background has been drawn for all the yokai, and in this scroll, Nurarihyon follows the style of *Gazu Hyakki Yagyo*. There are backgrounds to many of the other scenes, something that is somewhat unusual when compared with other illustrated-guide-like yokai picture scrolls, which typically only feature the yokai. The drawing of a background may have been intended to enhance the storytelling nature of the scroll.

p39

⑩

百物語化絵絵巻
Hyaku Monogatari Bake-e Picture Scroll
妖怪図鑑的の絵巻だが、いくつかの妖怪には名前だけではなく、妖怪のしゃべったような言葉なども記されており、興味深い資料となっている。巻末にはこの絵巻が「百物語化絵」であること、安永9(1780)年に方郁なる人物が描いたことなどの記載がある。方郁については不詳。「あかんべい」など、ほかの絵巻には収録されていない妖怪も散見でき、妖怪図鑑的絵巻の広がりを知ることのできる資料としても貴重である。
An illustrated-reference-book-like picture scroll, of great interest in that it records not only the names of the different yokai, but in some cases the sounds or words they speak.

p42

⑪

化物づくし絵巻
Bakemono-Zukushi Picture Scroll
21種類を収録した妖怪図鑑的絵巻。妖怪のほとんどはよく知られたものばかりだが、この絵巻の大きな特徴は名前が同じでも描かれた姿は一般的なものと異なっていることである。同じ妖怪でもビジュアル情報は統一されるまでには何種類もあったであろうことが想像できるが、この絵巻はそれを裏付ける資料と思われる。この絵巻のビジュア

ル情報の系統解明は今後の課題といえる。
An illustrated-reference-book-like yokai picture scroll featuring 21 types of yokai. Most of the yokai are well known but what characterizes this picture scroll is the fact that, although their names are the same, the yokai here look different from their typical forms. It is conceivable that, before uniformity took hold among the Japanese people in the visual depiction of the yokai, there were several versions of the same yokai, and this picture scroll supports that theory.

p44

12

ばけもの絵巻
Bakemono Picture Scroll
何話もの短い妖怪譚を収録した百物語的絵巻。収録された12話は東北から近畿まで各地にわたるが、この絵巻の類例は確認されておらず、それぞれの話はどのように伝えられて、いかなる経緯で収録されたかなど不明な点が多い。絵はユーモアのある筆致で怖さは感じられない。絵には100字足らずから数百字程度の物語が添えられている。巻末に「ばけものの終」とある。作者は不詳だが、明治時代に描かれたと推定される。
A *hyaku monogatari* (hundred ghost stories) picture scroll featuring short episodic yokai stories. The twelve stories spread throughout Japan from the Tohoku to the Kinki areas. The humorous style of the pictures contains no sense of fear. The artist is unknown.

p46

13

変化絵巻
Henge Picture Scroll
詞書はなく上、中、下の3巻からなり、江戸時代初期〜中期の作品と思われる。同種の絵巻は菱川師宣と菱川派の合作（ビゲロー・コレクション）など数本が確認されているほか、写本も存在する。
The existence of several picture scrolls of the same type including some by Hishikawa Moronobu and collaborations of the Hishikawa school have been confirmed (such as those in the Bigelow collection) as well as copies of those scrolls.

p50

14

二才絵巻
Nisai Picture Scroll
題箋に「二才絵巻」とあるが、一般的には「大石兵六物語」と呼ばれる。「二才」とは「青二才」などとして使われる言葉で、若僧を意味し、若侍の大石兵六のことを指すと思われる。
The word "*nisai*" means a young man and in this case is thought to refer to Oishi, a young samurai.

p52

15

神農鬼が島退治絵巻
Shinno and the Vanquishing of the Yokai on the Mythical Island of Demons Picture Scroll
放屁で妖怪を退治するといった内容で妖怪たちは愛らしく、畏怖する存在としての妖怪というよりも黄表紙などに登場するキャラクター化された怖くない妖怪として描かれており、江戸時代後期の制作といえよう。題は箱書によるが、一般的には「神農妖怪退治絵巻」として知られている。
The yokai are adorable (even if the story is about how they were vanquished by Shinno breaking wind).

p56

16

お化け絵巻
Obake Picture Scroll
題は共箱による。巻末には「陽城戯写」とある。岡島陽城の経歴は不詳。明治時代の作と推定される。

p58

⑰

付喪神絵巻
Tsukumogami Picture Scroll

煤払いで打ち捨てられた古い器物が人間に怨みを持って仇をするものの仏教に帰依して成仏するといった内容。器物たちは妖怪と化して宴会や博打といった人間たちの楽しみを謳歌し、悪行を繰り返すが護法童子に降伏して仏教に目覚めることとなる。器物のようなものでも成仏するといった仏教の有難さを伝えるのが絵巻の本旨だ。器物が妖怪となるという内容は歳を経た器物は魂を宿すといった思想が背景にあるからだ。百鬼夜行絵巻は付喪神絵巻の行列の場面がベースになっているとの説もある。
巻末には寛文8 (1668) 年と享保13 (1728) 年に伝写されたことが記されており、この絵巻が描かれた経緯がうかがえる。

A *tsukumogami* picture scroll shows how, although the household objects discarded when the house is being cleaned harbor grudges and cause harm to human beings, they attain Buddhahood by converting to Buddhism. The objects turn into yokai, indulging in banquets and other human pleasures such as gambling and committing misdeeds over and over again, but by surrendering to *goho-doji* (a child acolyte), they are awakened to Buddhism. The purpose of the scroll is to convey the virtue of Buddhism that even lowly household objects can attain Buddhahood. The subject matter of the scroll where household objects become yokai is based on the idea that household objects that are many years old harbor spirits. A theory also exists that the Night Parade of One Hundred Demons picture scroll is based on the procession scene in the *tsukumogami* picture scroll.

p62

⑱

百鬼夜行絵巻
Night Parade of One Hundred Demons Picture Scroll

淡彩で所々に色指定の書き込みがあることから下絵と思われる。巻頭裏面に「茶器夏巻之内　百鬼夜行之巻」とあることから四季をテーマとした茶器の絵のうちの夏バージョンとして描かれたものらしい。「竹義堂塩川文麟筆写」「河辺文庫」などの記述もあり、「河辺家書画記」なる落款も確認できる。塩川文麟は幕末から開化期の京都画壇の絵師で明治10 (1877) 年没。

p64

⑲

百物語絵巻
Hundred Ghost Stories Picture Scroll (*Hyaku Monogatari Emaki*)

地の巻末に明治4 (1871) 年に描かれたことが記されている。林熊太郎については不詳。

p70

⑳

稲生物怪録絵巻
Ghost Experience of Mr. Ino Picture Scroll (*Ino Bukkai Roku Emaki*)

この絵巻はポピュラーな稲生物怪録絵巻とは異なり、稲生武太夫（成人になった後の平太郎の名）の同僚だった柏正甫が武太夫から聞いた話を記録した内容が絵巻として描かれている。この種類の絵巻が確認されたのは近年になってからのことで、現存数も少ないと思われ、詳細な検討や位置づけは今後の課題といえる。5本の指がそれぞれ腕となり、さらに小さな指を有する巨大な腕が出現した場面と壁にいくつもの顔が現れた怪異など、いずれもポピュラーな稲生物怪録絵巻には描かれていない。

This picture scroll, unlike the popular version of the Ino Ghost Story Picture Scroll shown on page 64, depicts the story as told to and documented by Kashiwa Seiho, a colleague of Ino Budayu (the name assumed by Heitaro upon reaching adulthood). Because this version of the picture scroll has only recently been identified, it is believed that extant

examples are few in number. Neither of the scenes shown here – the appearance of a gigantic arm whose five fingers become arms, each bearing another set of tiny fingers; and ghosts, all with different faces, looming on a wall – appear in the popular version.

p78

21

画図百鬼夜行
Illustrated Night Parade of One Hundred Demons
(*Gazu Hyakki Yagyo*)
妖怪図鑑的版本のさきがけ的存在で、石燕が古画の妖怪図などを参考にして描いた。以後『今昔画図続百鬼』『今昔百鬼拾遺』『百器徒然袋』が続いて刊行されている。
Sekien later published the trilogy titled The Illustrated One Hundred Demons from the Present and the Past, Supplement to the Hundred Demons from the Present and the Past, and the Illustrated Bag of One Hundred Random Demons.

p80

22

怪物画本
Illustrated Book of Monsters
「巻一」となっているが、「巻二」以降は未見。

p82

23

絵本百物語
Picture Book of a Hundred Ghost Stories (*Ehon Hyaku Monogatari*)
全5巻からなり、45種類の妖怪を収録している。各地に伝わる妖怪話を多色刷りで紹介しており、妖怪図鑑的要素も備えている。絵は古くから伝えられていたものではなく、話に出てくる妖怪を新たにビジュアル化している。
Consisting of five volumes in total and containing 45 different kinds of yokai, the book presents in full color the yokai from each region of Japan and has elements of the style of an illustrated reference book. It contains many new types of yokai.

p116

42

後鳥羽法皇の夢中に現われたる妖怪図
Yokai Appearing in a Dream to the Retired Emperor Go-Toba
百鬼夜行絵巻の影響もみられるが、最後の場面は昇る太陽の中心に仏が描かれている。妖怪たちの行列を大錦6枚続という大きな構成で余すところなく表現している。
The final scene shows Buddha at the center of a rising sun. The procession of yokai is shown on a large scale across six large-format *nishiki-e*.

p118

43

和漢百物語
One Hundred Ghost Stories from China and Japan
1. 源頼光が病に伏せっていると土蜘蛛が妖怪となって出現するが、名刀・蜘蛛切丸によって切られてしまう。2. 滅ぼされた平将門の本拠・相馬古内裏で将門の娘・滝夜叉姫の妖術で出現した戦う骸骨たち。大宅太郎光圀は瀧夜叉姫を征伐するために相馬古内裏へ乗り込んだ武将。
3. 河内の農夫・鷺池平九郎が釣りをしていると水面に映ったのは平九郎をひと呑みにしようとしている大蛇。豪胆な平九郎は拳で打ちつけ、ついには引き裂いてしまった。4. 弓術に秀でた田原（俵）藤太は瀬田の龍女を悩ます三上山の大百足を一矢のもとに退治した。5. 周の武王が殷の紂王を滅ぼそうとしたときに千里眼、順風耳という2つの鬼に妨げられたが、雷震が2鬼を退散させた。6. 蒲生貞秀の家臣・登喜大四郎が古寺の怪事を耳にして行ってみると異形の化物が現れた。なかでも仁王の妖怪が大四郎につかみかかったが、それを力

任せに投げると消えてしまった。7. 忠臣・荒獅子男之助は連判状をくわえた鼠を鉄扇で打ちつけるが、その鼠はお家乗っ取りを謀る仁木弾正が化けたものであった。8. 源頼光の四天王の一人・卜部季武が乳飲み子を抱いた不気味な女に出会い、睨みつけると女は消えてしまったが、これが産女と呼ばれるものだ。9. 公孫勝が妖術を駆使して暴風、逆浪をおこし、その中に竜を出現させて天へと昇っていった。10. 楠正成の息子・正行は勇猛で、幼いころに妖怪を退治したが、妖怪の正体は古狸だった。

p123

45

源頼光土蜘蛛ヲ切ル図（新形三十六怪撰）
Minamoto no Yorimitsu Slashes the *Tsuchigumo* (New Forms of the Thirty-six Ghosts)

源頼光を襲った土蜘蛛の故事については多くの絵師が描いているが、ここでは芳年のイメージで独特の世界を創り出している。巨大な土蜘蛛は恐ろしいというよりも滑稽味のある姿をしている。
Many artists have depicted the scene in which Minamoto no Yorimitsu battled the *tsuchigumo* but here Tsukioka Yoshitoshi has produced the unique world that existed in his imagination. The *tsuchigumo* does not have its usual fearsome form. Instead it has a somewhat comical appearance.

p126

49

佐藤正清四国征伐ノトキ小曽か部元親ノ本城を責落ス折カラ不計深山ニ立入怪物退治ノ図
Sato Masakiyo Vanquishing Yokai at the Time of the Shikoku Conquest

#48とは背景も左右に幾筋もの赤い線が描かれるなどの違いがみられ、異版を示す資料といえる。
The background and the vertical red lines running through the drawing are also points of difference with the *nishiki-e* above.

p130

51

道化百物かたり
Doke Hyaku Monogatari

この絵は妖怪たちの百物語というスタイルをとって幕末の政治動向を描いていると思われる。
It is thought that the *hyaku monokatari* style was adopted to portray political developments in the last days of the Tokugawa shogunate.

p132

52

新案百鬼夜行（滑稽倭日史記）
New Design Night Parade of One Hundred Demons

大錦9枚という大きなスペースの上段に「新案百鬼夜行」下段に「全勝祝祭神事行燈」なる風刺画が描かれているが、そのテーマは日清戦争で、どちらも清国を揶揄する内容。「新案百鬼夜行」では妖怪たちは清国兵で、最後に昇る太陽（日本を意味する）によって逃げ惑っている。絵巻をひもといたような工夫が冒頭と末尾の絵からみてとれる。百鬼夜行絵巻はこんなところにも影響を与えているのだ。
On the top part of the nine large-format *nishiki-e* is the "New Design Night Parade of One Hundred Demons" and on the bottom, the *Zensho Shukusai Shinji Andon* caricatures. The subject is the Sino-Japanese War and both paintings are making fun of Qing Dynasty China. In the "New Design Night Parade of One Hundred Demons," the yokai are the Chinese soldiers who at the end are running around trying to escape because "the sun is rising."

p142

56

髪切の奇談
The Strange Tale of the *Kamikiri*

こうした事件を描いた錦絵は明治時代に新聞で報道された出来事を錦絵化する新聞錦絵のさきがけ

的存在といえる。

The *nishiki-e* that depicts this event was the first in a long line of "newspaper *nishiki-e*" where events reported in the newspaper in the Meiji period were turned into *nishiki-e*.

p164

62

新板四天王土蜘蛛退治飛廻双六
Shinpan Shitenno Tsuchigumo Taiji Tobimawari-Sugoroku

源頼光の四天王が土蜘蛛を退治するという有名な故事がタイトル。振り出しでは四天王が土蜘蛛退治を謀議する場面。退治した土蜘蛛の場面が上がりとなっているものの、それ以外の場面のほとんどは器物の妖怪であり、器物の妖怪を収録した双六に分類できよう。

The name of this *sugoroku* refers to the famous story of Minamoto no Yorimitsu's four legendary retainers vanquishing the *tsuchigumo*. The game begins with a scene in which the four retainers are conspiring to vanquish the *tsuchigumo* and ends with a scene in which the *tsuchigumo* is vanquished. Most of the scenes, however, feature household-implement yokai.

p166

63

おばけ双六
Obake Sugoroku

「バケチョーチン」「カサオバケ」などの器物の妖怪や「カニオバケ」「ウマムスメ」などの動物妖怪から「オイワ」「ヒノタマ」といったものまで、さまざまな種類を思いつくままに収録しているようだ。一般的な双六のレイアウトとは異なり、一つ一つの場面は四角、丸、三角など多様で、デザインの工夫がみられるところが興味深い。

This *sugoroku* randomly incorporates various types of household-utensil yokai such as the "ghost paper lantern" and the "umbrella ghost," animal yokai such as the "crab ghost" or the "horse daughter" and the ones referred to as "oiwa" and "fireball."

p168

64

滑稽ばけもの双六
Kokkei Bakemono Sugoroku

明治の木版画家小林清親の弟子で漫画も数多く描いた田口米作によるもので、各場面がストーリー性を有する新しい発想で制作された双六といえる。振り出し（右下）が妖怪話の場面なのもストーリー性のある双六にふさわしい。上がりは太陽が昇り始めて妖怪たちが逃げ去る場面となっている。

A *sugoroku* drawn by Taguchi Beisaku, who is also known as a manga artist. Each of the scenes is based on a new idea that has a story-telling quality. The aim is to reach the scene in which the yokai are all fleeing as the sun starts rising.

p173

65

化物つくし
Bakemono Tsukushi

左右、上下それぞれ8分割されてはいるものの上下2段で画面を構成しており、一つ一つの化物の紹介というよりも2段使ってそれぞれの画面にストーリー性を出しているところが特徴だ。右下と左下ではさらに大きなスペースで画面を構成している。上部にトリミングがあり、その部分にタイトルが書かれていたものと思われる。

This *tsukushi-e* consists entirely of sets of two vertical panels. Instead of introducing individual monsters in each panel, the pair of panels tell a story. The pictures at the lower left and lower right are of a larger size.

p170

66
しん版おばけ尽
Shinpan Obake Tsukushi

化物つくし絵は画面を分割していくつもの妖怪を描いているが、この絵は左右を11分割、上下を7分割した77種類もの妖怪を登場させている。化物つくし絵のなかでも描かれた数は多いほうだ。バックは赤色と青色を交互に使っている。

Bakemono tsukushi-e are typically divided into individual panels, each containing a picture of a yokai. This drawing is one of the larger ones, with 77 different kinds of yokai. The background of the panels alternates between red and blue.

p171

67
新板おばけづくし
Shinpan Obake Tsukushi

左右を6等分、上下も6等分したスペースにさまざまな妖怪が描かれている。妖怪の背景は、黄色と桃色の横列が交互に使われている。

Various yokai make an appearance on this six-across, six-down board. The rows have an attractive yellow and pink background.

p172

68
新板おどけばけ物つくし
Shinpan Odoke Bakemono Tsukushi

大坂で出された化物つくし絵で、タイトルを右にレイアウトしているのも特徴である。また、タイトルのバックにも細密なデザインがなされ、それぞれの妖怪も丁寧に制作されており、化物つくし絵としてはかなり上質の作品となっている。

The background to the title, which has been laid out vertically, has an intricate design and each of the yokai has been drawn with great care. For a *bakemono tsukushi-e*, this is one of considerably high quality.

p174

70
ばけもの尽
Bakemono Tsukushi

左右8分割、上下6分割で計48種類の妖怪を描いている。化物つくし絵には新しくつくられた妖怪も多いが、ここでもその傾向がうかがえる。

Many new monsters were specially created for the *bakemono tsukushi-e* and this is one example.

p175

71
新板化物つくし
Shinpan Bakemono Tsukushi

左右6分割、上下10分割で60種類の妖怪を収録している。多くの場合、分割は縦長の短冊型が多いが、ここでは正四角形である。

Bakemono tsukushi-e were generally composed of a set of rectangular panels, but this one has been divided into squares.

p176

72
新板化物づくし
Shinpan Bakemono Tsukushi

左右、上下それぞれ6分割して36のスペースをつくっているが、上段右端、上段右から3番目、上段左から2番目、3段目右から2番目、3段目左端、5段目右端、5段目左から2番目などは下のスペースも使って場面を構成、さらには5段目右から2番目と3番目と6段目右から3番目という変則的な3つのスペースを利用するなどの新しい工夫によって、動きのある化物尽くし絵をつくりあげている。

This *bakemono tsukushi-e* is divided into 36 panels.

But look closely, the artist has taken a new approach by linking two or three vertical panels in some to create a sense of motion.

p177

(73)

しんばんおばけづくし
Shinpan Obake Tsukushi
縦、横をそれぞれ4分割し16種類の妖怪を描いている。いわゆる「お化け尽くし」は数十種類の妖怪を収録しているケースが多いことからすると、この作品は極端に少ないので、一つ一つの妖怪を作品として見せる意図が強いと思われる。
This *bakemono tsukushi-e* depicts 16 different yokai, laid out four down, four across. As *bakemono tsukushi-e* typically featured dozens of yokai, this work is notable for having extremely few, the intent, it is believed, was to show each yokai as an individual artwork.

p178

(74)

化物つくし
Bakemono Tsukushi
題名は書かれていないが小型の化物つくし絵で、動物の妖怪を中心に描かれている。それぞれの妖怪には名前も記されている。
A small-scale *tsukushi-e* featuring mainly animal yokai.

(75)

妖物つくし
Bakemono Tsukushi
短冊型の化物つくし絵で、中央に「新板蝿からくり」なるタイトルと轆轤首が描かれ、左右に5場面ずつ妖怪がある。短冊型の化物つくし絵は希少である。
Long, vertical-format *bakemono tsukushi-e* are rare.

p179

(76)

しん版おばけのよめ入
Shinpan Obake no Yome-iri (Monsters' Wedding)
化物の嫁入りをテーマとした作品は草双紙、錦絵、絵巻などが確認できるが、この錦絵は10場面に分割して見合い、結納、お披露目などを1枚のなかに描き収めている。3枚で全ストーリーを描いた錦絵も存在するが、そこでは見合い話が持ち上がったところから子供が生まれて宮参りするところまで収録している。
Versions of the *bakemono* Wedding have been discovered in picture books, *nishiki-e*, and picture scrolls. This *nishiki-e* has been divided into ten scenes, each frame showing something related to the process of getting married: the *omiai*, the exchange of betrothal gifts, the presentation of the newly married couple and so on. There are *nishiki-e* that depict the whole process in just three frames but they start with the proposal of marriage and end with a child being born and taken to visit a shrine.

p183

(78)

怪談相馬内裏
Ghost Stories of the Soma Imperial Palace
紙をめくり場面を変えることで、妖怪たちの跳梁跋扈ぶりをみることができるよう工夫されている。左上の将軍太郎は将門の長子とされる。
It has been designed in such a way that you can see the rampaging of the yokai when you turn over the paper flaps.

p187

(81)

からくりお化け行灯
Karakuri Obake Lantern
慶応4(1868)年に出された歌川芳藤のからくりお化け行灯のデザインを一部取り入れながらも新しい場面を加えて、新たなからくりお化け行灯をつくりあげている。この行灯も平面図を切り抜いて立体化したものである。
This lantern incorporates parts of the design of the *karakuri obake* lantern on page 188 but has been updated by the addition of some new scenes.

p192

(85)

紙芝居　怪談百物語の内　鬼火河岸 52話
Kamishibai: Onibi Riverside Stories, Hundred Ghost Stories #52
この紙芝居は52回目のものだが、一つの話が数十回も続くケースもあった。表紙には「脚色・入江将介　線・森島　色・東彩生」とあり、共同作業で作られていたことがわかる。

p197

(86)

紙芝居　怪談百物語の内　お千代鴉 19話
Kamishibai: Ochiyogarasu, Hundred Ghost Stories #19
「脚色・入江将介　線・森島　彩色・東彩生」とあり、「鬼火河岸」と同じスタッフによって作られた紙芝居だ。この作品は19回目のもの。
A *kamishibai* made by the same people as made *Onibi* Riverside Stories on page 196.

p212

(101)

百鬼夜行図着物
Kimono with Night Parade of One Hundred Demons Pattern
矛を担いで褌姿で走り抜ける青鬼、災いを祓う大幣を突き出しながら突進する赤鬼、真っ赤な幡をかざした妖怪、走る三つ目の妖怪、絵巻の最後に登場する巨大な火の玉の出現に驚愕する妖怪など、真珠庵系のポピュラーな絵巻に描かれた妖怪がデザインされているが、絵巻では頭に経巻を載せた羽のある妖怪は、この着物では単なる天狗のような描かれ方となっているようだ。妖怪の背景にある黒い流れのようなラインは闇を表現しているものだろう。こうした特異なデザインの着物は一般的需要によるものとは考えにくく、趣味的需要でのあつらえだったのかもしれない。
The kimono has a pattern of blue demons clad in loincloths carrying pikes, red demons waving streamers attached to long poles to expel misfortune, yokai holding aloft bright red flags, yokai with three eyes and yokai startled at the huge fire ball that appears at the end of the picture scroll. The flowing black lines in the background to the yokai represent darkness. It is unlikely that a high demand existed for kimono with a pattern such as this one. It was possibly made to order for a customer with unusual taste.

p214

102

妖怪図着物
Kimono with Yokai Pattern
ここに描かれた妖怪は百鬼夜行絵巻には描かれていないものが多いが、頭に五徳を載せて火吹き竹を吹く三つ目の妖怪のように、百鬼夜行絵巻に登場するものもある。そうしたいくつもの妖怪たちが廃屋の朽ち果てた床の下にうごめいている図柄は、この着物のためにデザインされたと思われる。絵巻にはないデザインが着物のなかで展開されているのは妖怪文化の広がりといった視点からも興味深い事例といえよう。

The pattern here, in which yokai who appear in the Night Parade of One Hundred Demons Picture Scroll (such as the three-eyed yokai wearing trivets on their heads and blowing into bamboo blowpipes used for starting fires) are wriggling around under the decayed floor of an abandoned house, was designed specially for this kimono. The fact that a design that did not come from a picture scroll was deployed on a kimono is also interesting from the perspective of the development of Japanese yokai culture.

p216

103

異形賀茂祭図名古屋帯
Nagoya Obi with Atypical Kamo Festival Pattern
妖怪たちが賀茂祭の行列を繰り広げる絵巻は江戸時代の絵師田中訥言などによって描かれているが、この帯では賀茂祭の妖怪からいつくかをピックアップして刺繍によってデザインしている。
An obi embroidered with characters from a picture scroll in which a procession of yokai at the Kamo festival unfolds.

p218

104

茨木童子図名古屋帯
Nagoya Obi with Ibaraki-doji Pattern
京の都を荒らし回った鬼の茨木童子は渡辺綱に腕を切り取られ、その腕を取り戻すために綱の伯母に化けて綱に近づき、腕を取り戻して天空に逃げ去るといった有名な物語をテーマにしたもので、老婆姿の茨木童子が取り戻した自分の腕を抱えて天空に逃げるこの構図は錦絵などにも描かれたもっとも知られているクライマックスの場面である。茨木童子が綱に腕を切り落とされた場所は一条戻橋と羅生門の2説があるが、この帯では橋が描かれていることから一条戻橋の設定だろう。
The demon Ibaraki-doji, who rampaged his way around the city of Kyoto, had his arm cut off by Watanabe no Tsuna, and in order to retrieve his arm, turned himself into Tsuna's aunt, closed in on Tsuna, retrieved his arm and disappeared into the sky. The pattern on this obi is based on this famous story. The composition of the pattern in which Ibaraki-doji in the guise of an old woman escapes into the sky carrying his arm is also used in *nishiki-e* and is very well known.

p220

105

鵺図刺子半纏
Quilted *Hanten* with *Nue* Pattern
鵺は顔が猿、足が虎、尾は蛇という異形な姿で、不気味な泣き声は不吉なものとして恐れられたが、二条天皇は鵺の出現によって病に臥し、弓の名手である源頼政が鵺退治を命じられる。頼政は誰も手に負えなかった鵺を見事に退治して天皇の病は回復したという。鵺退治の話は源頼光の酒呑童子や土蜘蛛退治の伝説と同じようによく知られており、錦絵にも多数描かれている。この半纏には中央に大きく鵺がデザインされ、さらに弓や鵺に命中した矢が描かれていることで、頼政の鵺退治の話をもとにしていることが窺われる。表の背側には大きく「鵺」字が書かれており、表裏一体で半纏のデザインをつくりあげている。襟には「三ツ日町消防団」「第二部消防手」とあり、この消防団に所属する団員の半纏だったのだろう。
The *nue* is a grotesque creature with the face of a monkey, the body and limbs of a tiger and the tail of

a serpent. Its eerie cry is feared as something sinister. Emperor Nijo fell ill when the *nue* appeared and Minamoto no Yorimasa, an acclaimed archer, was ordered to slay the *nue*. Yorimasa admirably slayed the unruly *nue* and the emperor recovered from his illness.

p222

106

九尾の狐図刺子半纏
Quilted *Hanten* with Nine-Tailed Fox Pattern
九尾の狐伝説は中国や天竺にも伝わっているが、日本では玉藻前なる鳥羽院の寵姫に化けて惑わすが、やがては退治される悪狐として知られている。
The legend of the nine-tailed fox exists in China and also India, but in Japan it is known as an evil fox who, after turning itself into the concubine Tamamo-no-Mae, bewitched the Emperor Go-Toba.

p232

112

土蜘蛛図刺子半纏
Quilted *Hanten* with *Tsuchigumo* Pattern
下部には頼光の四天王が碁を打っていた碁盤が描かれているが、頼光の館で碁を打つ場面は錦絵ではおなじみの光景。
On the lower half is the *go* board with which Yorimitsu's four legendary retainers were playing go. Scenes of playing *go* at Yorimitsu's castle are often seen in *nishiki-e*.

p239

119

妖怪図京焼鉢
Kyoto-ware Ceramic Bowl with Yokai Pattern
これらの妖怪は百鬼夜行絵巻などには描かれておらず、この鉢のオリジナルデザインと思われる。

p242

124

狐団扇絵
Procession Across the Bridge Led by Foxes (Flat Fan Picture)
団扇用に制作された錦絵で、デザインも団扇仕様となっている。川に架かった橋を鍬や鋤を毛槍のように掲げた農夫たちが狐に先導されて渡っている。遠方には鳥居も見えるが、稲荷神社か。
A *nishiki-e* that was produced for use on a round fan. The farmers who are holding up hoes and spades as if they are *keyari* (spears decorated with feathers) are being led by a fox across the bridge over the river. In the distance a *torii* (the gateway to a shrine) can be seen, possibly that of the Inari shrine dedicated to foxes.

p243

125

九尾の狐扇子
Nine-Tailed Fox Folding Fan
九尾狐と九尾狐が化けた妖艶な美女・玉藻前が同じ画面に肉筆で交互に描かれている。これを扇子に貼ると、開き方によって九尾狐が現れたり、玉藻前が現れたりする趣向だ。
This fan features alternating hand-drawn pictures of the nine-tailed fox and Tamamo-no-Mae, the nine-tailed fox who turned itself into a bewitchingly beautiful woman. Depending on the way the fan is opened, the picture is either the nine-tailed fox or Tamamo-no-Mae.

p244

126

化物団扇
Bakemono Flat Fan
同じ大きさの団扇3点に「化ケ地蔵」「小夜衣艸紙・

小夜衣」「河童の怪」が肉筆で描かれている。近年では夏のお化け大会などで団扇が配られたりするが、ここに紹介するように、江戸時代から涼をとるための団扇や扇子にも妖怪が描かれていた。怖さでひやっとするような絵柄が求められていたのかもしれない。

The *bakejizo*, Sayogoromo, and *kappa* on all three of these same-sized flat fans are hand-painted. In recent years, flat fans have been distributed at summer "ghost conventions," and as can been seen here, yokai have been depicted on folding and flat fans since the Edo period for cooling oneself in the hot weather. The kinds of patterns that made one's blood curdle with fear were in high demand.

今昔妖怪大鑑　湯本豪一コレクション
YOKAI MUSEUM
The Art of Japanese Supernatural Beings
from YUMOTO Koichi Collection

2013年7月12日　初版第1刷発行
2018年7月8日　　　第4刷発行

著者　　　　　　　　　湯本豪一
英訳　　　　　　　　　パメラ三木
アートディレクション・デザイン　庄子結香（カレラ）
アイコンイラスト　阿部伸二（カレラ）
デザイン（作品ページ）　公平恵美（ピエ・グラフィックス）
撮影　　　　　　　　　藤本邦治
協力　　　　　　　　　山九株式会社、酒井清一
編集　　　　　　　　　瀧 亮子

Written by Yumoto Koichi
Translated by Pamela Miki Associates
Designed by Shoji Yuko (Karera)
Illustlated by Abe Shinji (Karera)
Layout by Kohei Emi (PIE Graphics)
Photography by Fujimoto Kuniharu
Edited by Taki Akiko

発行人　　三芳寛要
発行元　　株式会社 パイ インターナショナル
〒170-0005　東京都豊島区南大塚2-32-4
TEL 03-3944-3981　FAX 03-5395-4830
sales@pie.co.jp

PIE International
2-32-4, Minami-Otsuka, Toshima-ku,
Tokyo, 170-0005 JAPAN
TEL +81-3-3944-3981　FAX +81-3-5395-4830
sales@pie.co.jp

印刷・製本　大日本印刷株式会社

© 2013 Yumoto Koichi / PIE International
ISBN 978-4-7562-4337-9 C0071　Printed in Japan

本書の収録内容の無断転載・複写・複製等を禁じます。ご注文、乱丁・落丁本の交換等に関するお問い合わせは、小社までご連絡ください。
All rights reserved. No part of this publication may be reproduced in any form or by any means, graphic, electronic or mechanical, including photocopying and recording by an information storage and retrieval system, without permission in writing from the publisher.

湯本豪一
Yumoto Koichi

1950年生まれ。川崎市市民ミュージアム学芸室長などを経て、現在妖怪研究、収集を行うかたわら、大学院や大学で妖怪などについて教えている。
主な著書に、『江戸の妖怪絵巻』（光文社新書）、『百鬼夜行絵巻』（小学館）、『帝都妖怪新聞』（角川ソフィア文庫）などがある。

Born 1950. Former curatorial director of the Kawasaki City Museum. Continues his pursuit of yokai-related materials in the form of research, collection, and teaching at the university and post-graduate level.

今昔妖怪大鑑絵葉書 YOKAI POST CARD

裏面の線に沿って切り抜いて使ってね。

おまけだよ
こわくないよ
にげろ〜
おやおや
きゃ〜
あら大変
これはこれは
にゃんとまあ
出た〜
うわ〜
ひえ〜
ぶるぶる

線に沿って切り抜いて使ってね。

うへへ

火気厳禁

POST CARD

おかまいなく

切手を貼ろう

POST CARD

わいわい

こりゃたまらん

あいつうまそうだ にゃんにゃん